New book design

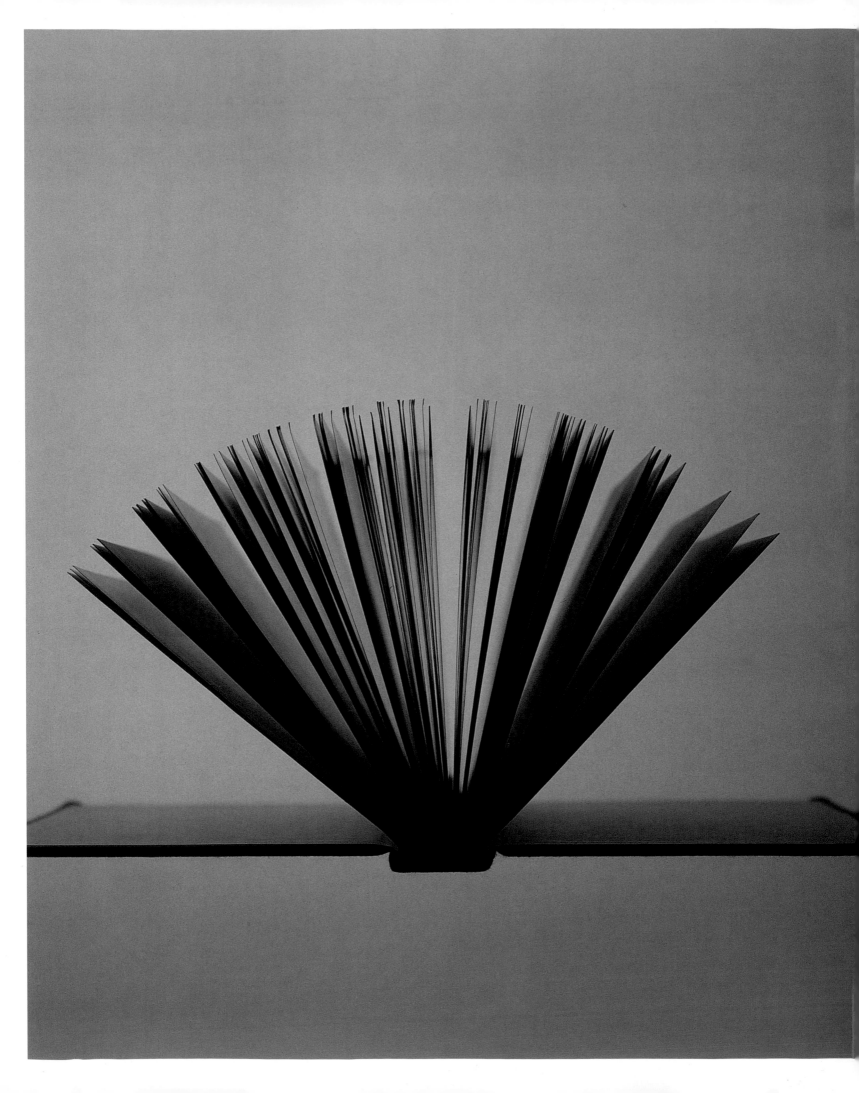

New book design

Compiled and edited by
Roger Fawcett-Tang
Introduction and interviews by
Caroline Roberts

Laurence King Publishing

Published in 2004
by Laurence King Publishing Ltd
71 Great Russell Street
London WC1B 3BP
United Kingdom

Tel: + 44 20 7430 8850
Fax: + 44 20 7430 8880
e-mail: enquiries@laurenceking.co.uk
www.laurenceking.co.uk

A catalogue record for this book is available
from the British Library

ISBN 1 85669 366 x

Designed by Struktur Design Limited
Picture research by Roger Fawcett-Tang
Photography by Roger Fawcett-Tang

Printed in China

Contents

Introduction

As the literary editor of one leading British newspaper pointed out recently, the book 'has kept pace with virtually every technological change you care to think of, from the internal combustion engine to television'. Indeed, though increasingly sophisticated production techniques have been developed and its external face has been subjected to the whims of any and every graphic design style currently in favour, the inside of the book has essentially kept the same format since the first 'codex' books were created by the Romans thousands of years ago.

The combination of the desktop publishing revolution, advances in print quality and the emergence of a global economy has led to more titles being published than ever before. Book design is increasingly important in the publishing process thanks to stiff competition between publishers and the development of a visually literate audience. When presented with two books offering roughly the same content at the same price, the increasingly design-conscious book-buying public will always choose the volume that is more attractive to look at, easier to read and that presents information in the clearest, most easy-to-understand manner.

Book design is one of the earliest examples of what we now call 'graphic design'. The Church was its first patron. In the West, the original book designers were 9th-century monks copying scriptures onto parchment, and the first attempts at printing were designed to emulate these beautifully hand-produced pieces. The designer Jan Tschichold spent many years examining these beautiful medieval and Renaissance manuscripts and books in an effort to discover their underlying design principles. After painstakingly measuring a wide variety of examples, he concluded that the majority used the proportions 2:3:4:6 for the size of their inner, top, outer and bottom margins respectively. He also found that the height of the text box equalled the width of the page where there was a page width/page height ratio of 2:3. This 'golden ratio', used by many (including Gutenberg), was first described in Tschichold's *The Form of the Book: Essays on the Morality of Good Design* (1955) and was instrumental in establishing the basic principles of modern book layout. Josef Müller-Brockmann's exploration of the grid system was another huge influence on post-war book design. Both he and Tschichold are still very important today. However, rules are made to be broken, and for every designer following the 'golden ratio' there are many more who are willing to throw the rulebook out of the window.

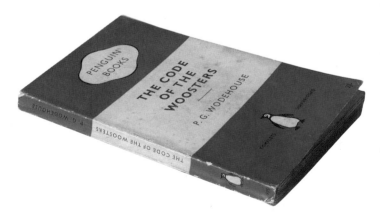

Introduction
006/007

Project: The Code of the Woosters
Author: P.G. Wodehouse
Publisher: Penguin Books
Size: 180 x 110mm (7⅛ x 4⅜in)
Pages: 240
Year: 1953
Country: United Kingdom

It is hard to generalize about current trends in book design. Editorial design (like any other type of design, such as packaging, annual reports, brochures, etc) is for ever subject to the constantly shifting directions and stylistic approaches that influence graphic design as a whole. While it is possible to note the popularity of a certain sans-serif typeface, or the growing use of a certain style of photography, the most significant trend in design at the moment is 'anything goes'. Designers will go to any lengths to create the design that is most appropriate to the book's content and its intended audience.

The single factor that has had the greatest impact across all genres of both fiction and non-fiction publishing is that of increased production values. The most lavishly produced books are generally those about visual culture; many use unconventional formats and unusual print techniques and materials, and are conceived to appeal to the design-literate consumer. For the most part, these are books made by designers for designers, and as such all the design elements (layout, typography, imagery) have to work even harder to satisfy this most discerning and critical section of the book-buying audience.

The standards set by these books have had a big influence on book design across other genres, a good example being the once-humble cookery book. These are now so concerned to combine seductive imagery and cool typography with clean layouts and high production values that the recipes have become almost secondary. Of course, the commercial success of these books is helped greatly by the celebrity status of the authors and TV tie-ins.

It was the 19th-century US clergyman Henry Ward Beecher who asked, 'Where is human nature so weak as in the bookstore?' Designers more than anyone seem happy to endorse his theory. Few of the books that we buy – with the exception of a dictionary or the Highway Code, perhaps – are, strictly speaking, essential purchases. Books are really just another way for us to relieve ourselves of our disposable income, and for this reason they have always had to possess an element of seduction. Although all the various elements (such as layout, typography, use of images, print quality, paper stock and finishing) combine to give an overall feel, it is the cover of a book that has to work the hardest. Whoever coined the phrase about never judging a book by its cover was misguided – the classics notwithstanding, if a book can't be bothered to attempt to gain your interest with its cover, then the chances are that what's inside will be equally dull. The design writer Alan Powers argues in his book *Front Cover: Great Book Jacket and Cover Design* that successful covers possess 'a form of hidden eroticism, connecting with some undefended part of the personality in order to say "take me, I am yours"'.

The concept of the cover design being a book's main selling point is relatively recent, however. Traditionally, when books were the prerogative of the very wealthy, the inside of a book would be typeset and printed by the printer, and a bookbinder would then create a binding in the style of the customer's personal library (invariably leather-bound and gold leaf-embossed). Cheap reprints of novels were available to the masses, but it was not until 1935, when the first ten Penguin Classics were launched, that 'quality' fiction and non-fiction were published for a wide audience of ordinary readers. The brainchild of Allen Lane, managing director of the Bodley Head, the venture was seen as a huge risk at the time. Design played a very important part in the series' success. Featuring a 'dignified yet flippant' logo (later redrawn by Jan Tschichold), simple typography and blocks of solid colour, these covers made the Penguin titles instantly recognizable. They used an easy colour-coding system: orange for fiction, dark blue for biography, green for crime, red for plays, cerise for travel and yellow for miscellanea. In a shameless piece of marketing, the price (a modest sixpence) was displayed prominently *twice* on the front cover.

As Penguin increased the number of its imprints, its covers became more adventurous. In the late Nineties, Penguin tried to inject new life into its Modern Classics series by commissioning some of the UK's most fashionable designers to come up with designs that would appeal to the under-25s. Despite being somewhat sniffily received by the purists, the new covers were a huge financial success and provided a perfect example of the importance of distinctive cover design.

Traditionally, it is the hardback edition of a book that has enjoyed higher design and production values. However, many publishers now offer 'paperback originals', which have some of the higher production values associated with their declining hardback editions and so neatly bypass the need for the hardback edition as a marketing tool. Things are slightly different in the United States. Unlike Europe, where margins are becoming increasingly tight, North America has an ongoing tradition of

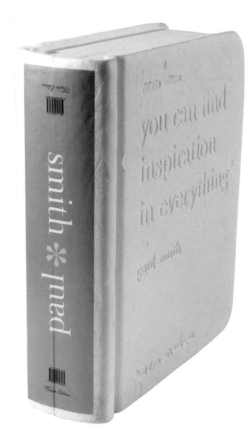

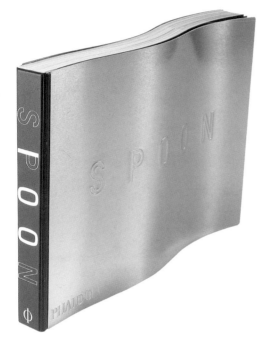

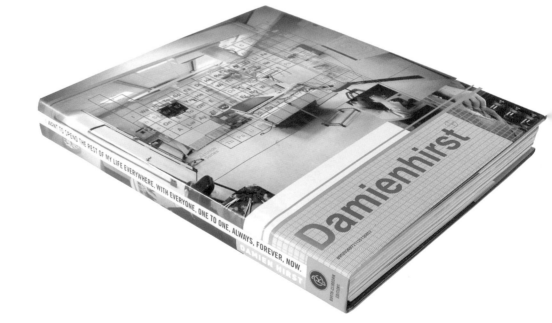

Project: Spoon
See page 25

Project: You Can Find Inspiration in Everything*
See page 16

Design/art: Jonathan Barnbrook/Damien Hirst
Project: I Want to Spend the Rest of my Life
Everywhere, with Everyone, One to One, Always,
Forever, Now
Publisher: Booth-Clibborn Editions
Size: 340 x 300mm (13½ x 11⅞in)
Pages: 334
Year: 1997
Country: United Kingdom

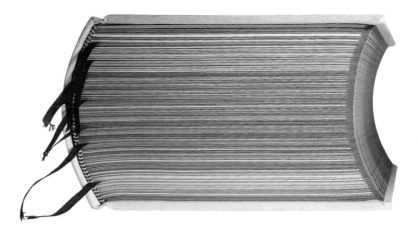

producing well-crafted hardback books. The bigger market for fiction there lends itself to higher print runs and therefore lower unit costs than in Europe. Publishers such as Knopf, for whom the celebrated designer Chip Kidd has produced over 800 covers, are renowned for their well-designed titles.

Whether for art and design or fiction titles, covers are exploited to create some kind of hype. Various novel techniques have been explored. Bruce Mau created ten different covers featuring different fabrics and colours for his 2000 book *Life Style*, designed and edited by himself. More recently still, *Freitag*, published by Lars Müller in 2002, was produced with multiple covers. The Freitag brothers make bags and accessories from recycled truck tarpaulins – every one is different, and to reflect this each copy of the book was bound with its own individual piece of tarpaulin.

*You Can Find Inspiration in Everything**, created for Paul Smith by Aboud•Sodano and published by Violette Editions, was bound in a piece of cloth cut from an assortment of fabrics from Smith's textile collection, giving each copy a totally original cover. Despite the fairly conventional format of the book itself, it is notable thanks to its oversized polystyrene case, moulded in the shape of a book. Designed by Jonathan Ive, it presented the design-conscious reader with a dilemma – while the cover is bulky and pretty much impossible to fit on a normal bookshelf, throwing it away is not really an option. As well as using a number of different paper stocks and print techniques, the book also features a paper pattern, a pull-out poster and its own magnifying glass.

It has become *de rigueur* for publishers of books on art, design and architecture to exploit different production techniques – whether it's the format, the binding, the cover material or the packaging – to appeal to their novelty-hungry target audience. A particularly lavish and significant example of this is Damien Hirst's book *I Want to Spend the Rest of my Life Everywhere, with Everyone, One to One, Always, Forever, Now*, published by Booth-Clibborn in 1997, which started a trend for monographs that did more than just showcase the artist or designer concerned. With its numerous pop-ups and cut-outs courtesy of designer Jonathan Barnbrook, the book was a radical departure from everything that had come before it, perfectly expressing Hirst's larger-than-life, media-savvy personality.

Taking things even further, numerous attempts have been made at creating books that, rather than just showcasing art, are themselves pieces of art. Most outrageous was surely Helmut Newton's *Sumo*, published by Taschen in 1999, which weighed in at 30kg. The book was printed in a limited edition and came with its own aluminium table, designed by Philippe Starck. Canongate and Damien Hirst's 1999 limited edition of Robert Sebag's *Snowblind* (priced at £1,000 a copy) came with a mirror cover, silver Amex credit card, introduction by Howard Marks and hidden $100 bill (the number on which corresponded to the edition number of the book). More conventional in format, but also more exclusive, was Irma Boom's 2,136-page book for SHV Holdings. Painstakingly put together over a five-year period with historian Johan Pijnappel, it was commissioned as a gift for the board and shareholders of the company. Until recently there were no copies in the public domain.

A trip to any bookshop specializing in art and design will provide an abundance of titles with 'interesting' covers – Phaidon's inflatable *Fresh Cream*, Laurence King's *Graphic Britain* with its peel-off GB stickers, and IDN's *Iconographics* with its embossed cover are well-known examples. Not many of these books actually push the design boundaries in terms of what's inside – most of the experimentation is limited to the cover, the format or the binding. A reason for this could be that foreign-language imprints are as important now as ever to a title's commercial success, so the treatment of the type inside has to remain comparatively conventional.

Spoon, published by Phaidon in 2002, took things a step further. A showcase for the work of 100 product designers, it has an extraordinary, OTT cover. Designed by Mark Diaper and produced in conjunction with Corus, it consists of curved pieces of lightweight polymer-coated steel in the shape of a spoon. On this occasion, the revolution does not end with the cover, as the pages inside the book follow the shape of the cover. Though it is visually stunning, it is also annoying to read and potentially damaging to the other books on your shelves. An honest attempt to add value and playfulness to a book, combined with an innovative use of material? Or a cynical marketing ploy?

Books that are aimed at the design market can usually be placed in one of three rough categories. Many are

Design: Irma Boom
Project: SHV Thinkbook
Publisher: SHV
Size: 226 x 170 x 114mm (8⅞ x 6¾ x 4½in)
Pages: 2,136
Year: 1996
Country: Holland

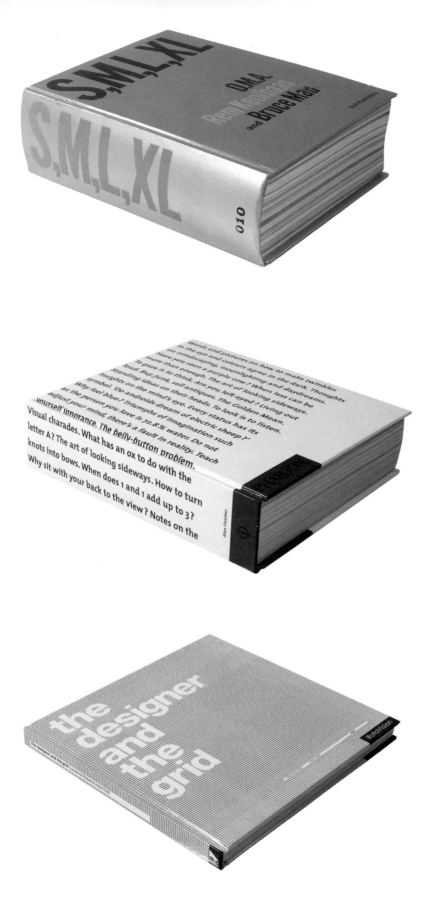

books aimed at helping the designer with his or her craft – in addition to the obvious software manuals, there are books on every aspect of how to design, how to use type, how to use colour, working with grids, problem-solving, etc. Then, by way of contrast, there are books whose main purpose is to inspire, showcasing everything from the coolest new graphic design to boring postcards and bar interiors. Perhaps the reason why this genre of book is so popular is because, as the pace of work increases, it becomes more and more difficult for designers to leave their office in search of inspiration. Lastly, there are the monographs – the definitive (or not) collection of an artist's or designer's works. Unfortunately, the ego-boosting idea of being both designer and editor, combined with the relative cheapness of publishing, has led some design consultancies to blur the boundaries between 'book' and 'self-promotional brochure'. Many are happy to publish a self-congratulatory volume full of 'personal work', often with little or no critical analysis. Perhaps what they find attractive about publishing a book is the idea of creating something that has a relatively long lifespan, unlike much of their other print-based work.

Increasingly designers are becoming editors themselves. *S, M, L, XL*, a collaboration between architect Rem Koolhaus and designer Bruce Mau published in 1995 by Uitgeverij 010, is one of the most significant examples of a book where the designer is given as much credit as the author. It is easy to forget the impact that this huge book had at the time of its first appearance. Publisher Lars Müller, who has been responsible for creating some of the most coveted art, design and photography titles of the last 20 years, designs and either edits or co-edits all of his books. Many design books fitting into the 'how-to' category (such as Michael Johnson's *Problem Solving*, Lucienne Roberts and Julia Thrift's *The Designer and the Grid* and Quentin Newark's *What Is Graphic Design?*) are written and designed by the same people.

The number of books aimed at designers seems to be growing at an astonishing rate, and it is hard to imagine that such an output can be sustained without some drop in quality, or boredom setting in as far as the public is concerned. While there are always a number of new, well-researched books every year, it is doubtful whether the majority of the titles

that currently reach the bookshelves will have any kind of longevity – a view held by many retailers as well as those within the design industry.

But while high-profile books like *Spoon* end up grabbing the headlines, there are plenty of other more low-key, but beautifully produced and thoughtful books that do not rely on novelty covers or flashy design and that sell steadily over a number of years. Designers such as Peter Willberg and publishers such as Lars Müller and the Hyphen Press have a loyal and dedicated following, and their books are as much content- as design-driven. It is surely the smaller independent publishers who are prepared to take more risks with content, rather than just design, who will flourish in the future, since they are more likely to produce titles with lasting appeal. Likewise much has been achieved by Alan Fletcher at Phaidon, Angus Hyland at Canongate and Vince Frost at Laurence King to improve the overall standard of design throughout the range of titles at these more mainstream publishers.

Can the book survive another 2,000 years? Not so very long ago the demise of the book was forecast – it is safe to say now that news of its impending death was greatly exaggerated. Much has been written about e-books and their potentially devasting effect on the world of publishing, and already many novels are available to download from the web. But as with most attempts at predicting how we will live our lives in the not-too-distant future, too much emphasis is being placed on the emerging technology and what it is capable of doing, and not enough on how it fits into the way we actually live. Perversely, it seems that the more screen-based society becomes, the greater the number of printed books that are being produced. Clearly our love affair with books is far from over.

Gutenberg's printing press, perhaps the most significant technological development in the history of the book, helped to expand the literary world, giving more people the opportunity to read, and talk and write about books. In the same way, the internet, rather than signalling the end of books as we know them, has made them more accessible than ever. Wherever you are in the world, websites such as Amazon have ensured that you can get a copy of almost any book you want delivered to your doorstep within a matter of hours. It is now easy to search for that impossible-to-find book on the net, or bid for a rare volume on one of the many auction sites.

Perhaps the real reason why e-books have never really taken off is the same reason why books have survived in their current format. We now spend most of our lives looking at screens – computer screens when we are at work, television and cinema screens when we are relaxing, and mobile and palm-top screens when we're going from one to the other. In such a context, printed books come as something of a relief.

Most people's relationship with books begins when they are very young, with the comforting childhood ritual of a book at bedtime. As well as being a bonding experience between parent and child, books represent a gateway into a land of fantasy, fuelling the child's imagination and introducing new ways of thinking and new ideas. The imagery on the pages of a children's book is one of our earliest and most lasting visual influences. Many graphic designers such as Bruno Munari and Paul Rand have been inspired to create their own children's books. Despite the fact that computer games and DVDs seem to be the pastimes of choice for today's culturally challenged children, whatever you think of it, the Harry Potter 'phenomenon' has proved that children still have a huge appetite for reading and are as capable of falling in love with books as ever.

Immersing yourself in a book, whether it's turning over the beautifully proportioned pages of a book on medieval manuscripts or racing through the high-octane pages of an airport-lounge James Ellroy paperback-*noir*, is one of life's greatest and most basic pleasures, and one that has remained virtually unchanged for centuries. Books play an important part in our lives – we turn to them for instruction, enlightenment and inspiration throughout our existence. In an increasingly disposable world, books represent permanence and continuity. The tactile quality of books is a joy that should not be underestimated. It is what will ensure their longevity. A future without books is unthinkable, and highly unlikely.

Packaging

The external appearance of a book is the most crucial factor in its ability to gain the attention of potential purchasers scanning the ever more crowded shelves of contemporary bookshops. Sales and marketing teams tend to favour 'the louder the cover the better the book's chances' philosophy of jacket design. However, this is not always the case. Qualities of stillness and calm can still generate interest in the consumer.

The packaging does not always stop at the inclusion of a pretty picture on the dust jacket. As the following selection of recent designs shows, a vast array of different materials and tricks can be used to add value and desirability to a book.

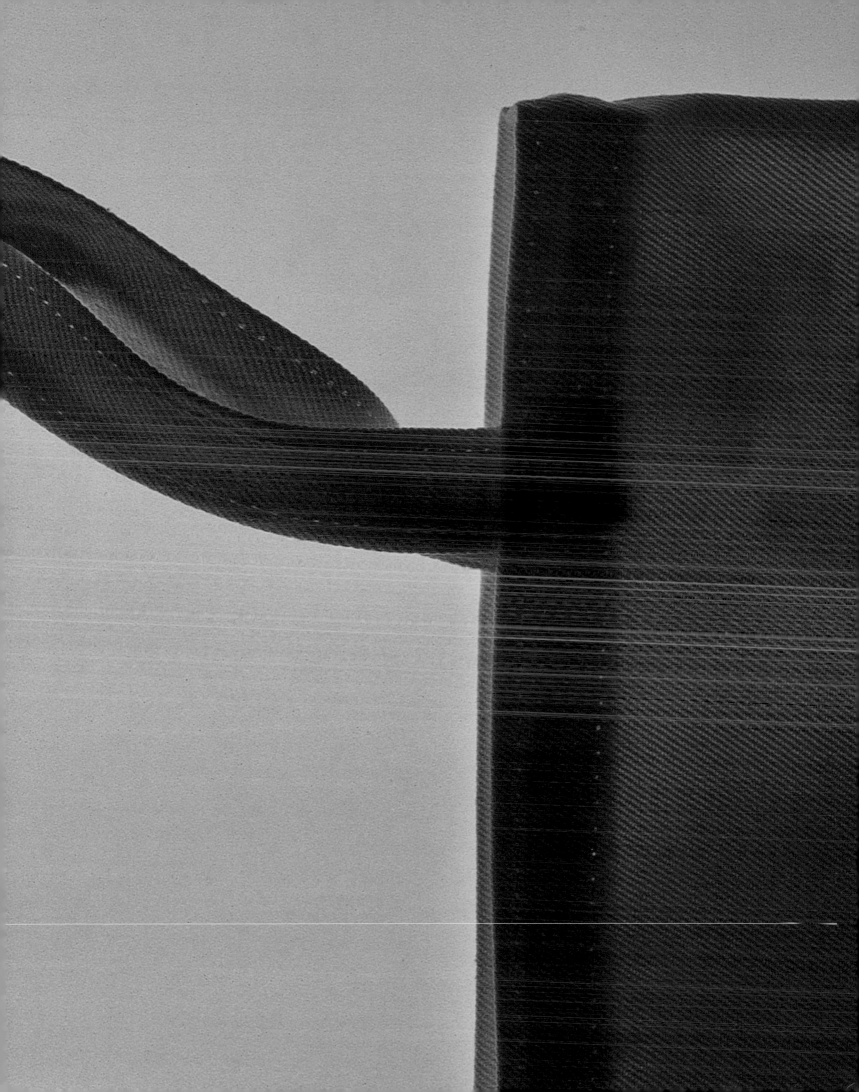

Interview:
Lars Müller,
publisher

'Where do you buy books?
'At your bookshop, of course!
'And so you should. You can touch them
there, compare them, put them down and have another think about
what you want to buy. Bookshops are good places to do this – and
important. Especially for my books! Online they are hot air and
interchangeable. When they're in your hand they have weight,
texture and content. That's why you need a bookshop. Buy your
books there. Your bookseller and I appreciate it.'

So reads the homepage of lars-mueller-publishers.com, which, needless to say, does not engage in e-commerce. Despite this impassioned plea, the Norwegian-born publisher is aware that, while designers might visit a bookstore to check out his latest offerings, they will not always buy his books there: 'Bookstores have become more like showrooms – many people go home and order at a discount from online bookstores. I know my books aren't cheap, and I understand that they must take advantage of that.'

It's true that Lars Müller's books aren't cheap, but they are without exception beautifully crafted and well researched, and consequently coveted by designers the world over. Müller is based just outside Zurich and, as well as publishing books, runs a design office that helps to finance the publishing side. He would love to become a full-time publisher: 'I am getting nearer to it – but not economically. My will is growing, though, so I will find a way sooner or later.'

He is in the unique position of both editing and designing a large percentage of the books he publishes. He entered the world of publishing after becoming disillusioned with working solely as a designer: 'You always need a client, but they just commission you to turn content into design. If you want to

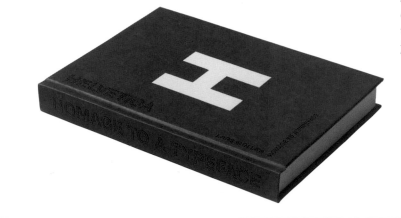

Project: Helvetica: Homage to a Typeface
See page 168

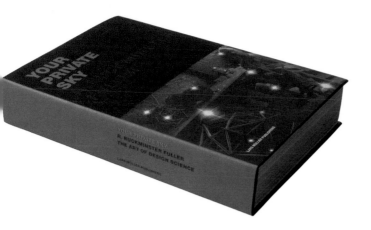

survive as a designer, you cannot be too critical about the content. You might refuse tobacco advertising, but the rest you have to accept.' Müller spent a year working with Wim Crouwel at Total Design in Amsterdam, where he learned a valuable lesson: 'Crouwel is very critical and ethical. He was more like a friend than a boss. He taught me that the art in life is to say no. You need somebody to tell you – I think life is too short to learn it for yourself.'

It was the permanent nature of books that attracted him to publishing: 'I found out that what I loved most was book design – for a very simple reason, which is that the book is actually the only kind of printed matter that is meant to last.' Müller's first book was on Swiss design in the Fifties and Sixties, a subject very close to his heart. Since then he has published books on, among others, Jasper Morrison, Ruedi Baur, Josef Müller-Brockmann, Bruno Munari, Nikolaus Troxler and Wolfgang Weingart, as well as a poster series. He has also recently published his much-anticipated *Helvetica: Homage to a Typeface*.

Müller feels that the recent influx of high-turnover books about design, architecture and photography may have a damaging effect on the industry as a whole: 'I think there is a certain overkill at the moment. We all know that there isn't any more money being spent on books – the same money is just being divided up between more books.' He is not impressed by the trend for designers or architects to publish books that are no more than glorified company brochures. 'I think the respect for books has been lost,' he suggests.

Müller has published over 200 titles, approximately half of which have been designed in his own studio. He stills remains endearingly modest about what he does: 'I'm always surprised if something is successful, because I have the habit of making books that I would like to buy myself. But that means I can't really calculate how many other people will share my opinion.' *Your Private Sky*, Müller's two-volume work on Buckminster Fuller, has been incredibly popular – there is now a Japanese edition and it has sold over 30,000 copies in total. Not bad for volumes that retail at 49 and 39 euros respectively. The Buckminster Fuller tomes are examples of books that have lasting appeal: 'They are contemporary, but they're not defined by the year they were published – it's more the decade. I hope they'll go on selling for the next ten years.' Certainly what differentiates Lars Müller's books from most of what is currently taking up shelf space in bookstores is their lasting appeal.

Your Private Sky had a long evolution period and a relatively short design stage. Müller describes it as being more like a 'visual reader' and the kind of book that he wants to publish more of in the future: 'It's actually visual, but it gives enough written information – let's say the text illustrates the images. You're drawn into it. Many people read through the entire book without realizing it because they were attracted by an image and they wanted to find out more.' He sees that this way of creating books could be applied to other areas outside design – to more 'important' topics. 'That has to do with getting a bit older,' he explains, 'and seeing that design is one thing that really doesn't change the world.' He has an ambitious project in mind – to try and visualize the concept of Human Rights, 'both the threatened and the perverse, all the extremes and polarities'.

Editing and designing books has been a rewarding and enlightening experience for Lars Müller and he is continually re-evaluating the process. 'I have realized that I believe in the value of design as much as ever,' he adds. 'But it has to have a very specific relationship to content. A wonderful poem stays a wonderful poem, even if it has an ugly design or bad typography, whereas excellent typography doesn't make a bad poem better…'

Design: Integral Lars Müller
Project: Your Private Sky: R. Buckminster Fuller,
 The Art of Design Science
Editors: Joachim Krausse & Claude Lichtenstein
Publisher: Lars Müller Publishers
Size: 245 x 170mm (9⅝ x 6¾in)
Pages: 528
Year: 1999
Country: Switzerland

Protection

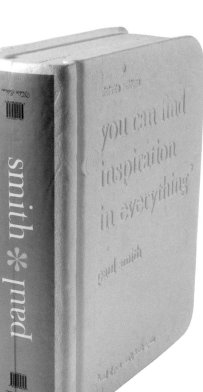

Design: Aboud•Sodano (case: Jonathan Ive)
Project: You Can Find Inspiration in Everything*
Author: Paul Smith
Publisher: Violette Editions
Size: 260 x 220mm (case: 332 x 285 x 93mm)
 (10¼ x 8¾in; case: 13⅛ x 11¼ x 3½in)
Pages: 296 + inserts
Year: 2001
Country: United Kingdom

Expanded polystyrene is used as outer packaging for this book about the British fashion designer Paul Smith. The form echoes that of a large leather-bound volume. The packaging provides more than just protection for the book during shipping; it becomes a kind of dust jacket that is both disposable and cherishable. Inside this custom case, the polystyrene structure carefully holds in place the book itself, which comes in a variety of cloth covers, all cut from a selection of the designer's textiles. In fact, owing to the varying crops of the different cloths, each cover is unique. The buyer has no idea what his or her cover will look like until the protective case has been cracked open.

The casing also houses a Paul Smith branded magnifying glass, partially as a visual pun on the title of the book. 'You Can Find Inspiration in

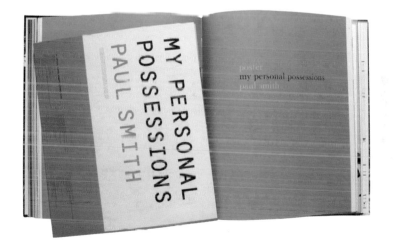

verything*' – '*And If You Can't, Look Again!'
 The book contains a variety of visual tricks,
ncluding pull-out comics and wallcharts. The first
ection includes an introductory text in a number
f different languages, with each successive
ersion printed on progressively larger pages.

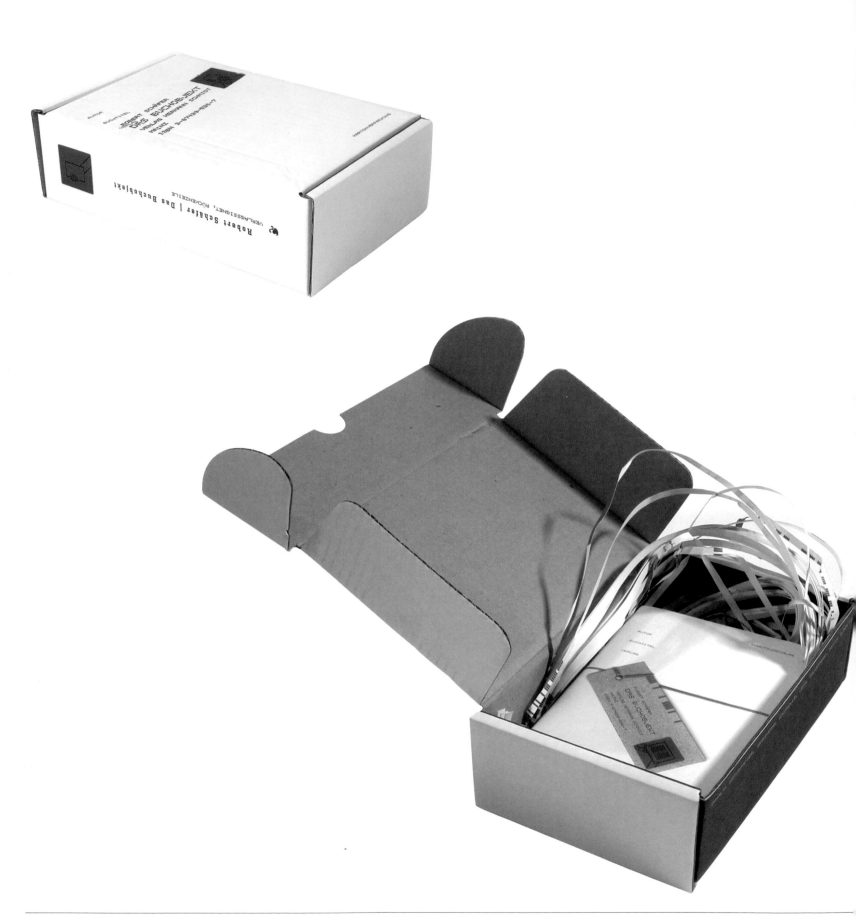

Design: Robert Schäfer
Project: Das Buchobjekt
Author: Robert Schäfer
Publisher: Verlag Hermann Schmidt, Mainz
Size: 185 x 132mm (box: 240 x 148 x 70mm)
⠀⠀⠀(7¼ x 5¼in; box: 9½ x 6¾ x 2¾in)
Pages: 194
Year: 1999
Country: Germany

A standard cardboard carton is used as the outer cover for this German work. Every detail has been carefully considered: the book sits in a nest of shredded paper, which on closer inspection turns out to consist of the offcuts of the book block itself. As such, in a sense *Das Buchobjekt* recycles the waste that its own production has generated.

The book contains a variety of typographic experiments, including a dramatic use of type on the open edges of the pages. On certain pages these word fragments are extended across the page in the form of a series of cross-hatched barcodes.

SEITE 37

SEITE 68

IN COLOUR,
IN SMELL – THE OLDER ONES
SMELL LIKE OLD BOOKS SHOULD:
DUSTY,
SLIGHTLY
MUSTY;
NEW BOOKS
SMELL OF PETROLEUM,
THINNER THAT GOES INTO INK.
MY BOOKS DIFFER

SEITE 68

SPIEGEL

VORDERES VORSATZ

ROBERT SCHÄFER, 1971 gebo..., hat Kommunikationsdesign in Ravensburg studiert. Seine studienbezogene Tätigkeit in einem Verlag regte ihn dazu an, »Das Buchobjekt« zu konzipieren und in einer kleinen Stückzahl selbst zu produzieren. Die Resonanz war so groß, dass »Das Buchobjekt« nun bereits in der dritten Auflage im Verlag Hermann Schmidt Mainz erscheint. Robert Schäfer lebt seit 1999 in Berlin.
robert.schaefer@web.de

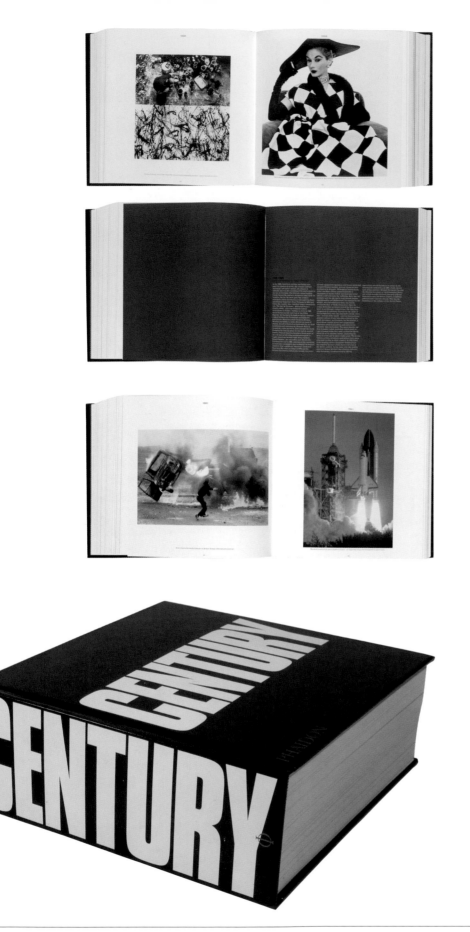

Design: Karl Shanahan
Project: Century
Author: Bruce Bernard
Publisher: Phaidon Press
Size: 256 x 259mm (10⅛ x 10¼in)
Pages: 1,120
Year: 1999
Country: United Kingdom

Weighing in at 5kg (11lbs), *Century* is conveniently supplied with its own reinforced carrying case. The book provides a photographic record of the last 100 years and includes many of the most iconic images ever captured on film. The layouts are kept clean and simple: there is one image per page, and the background information for all of the pictures within any given section is grouped together.

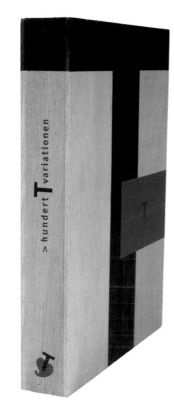

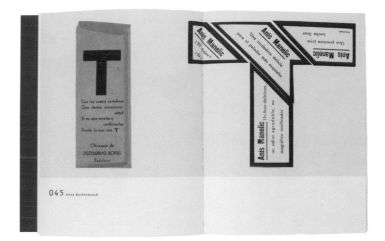

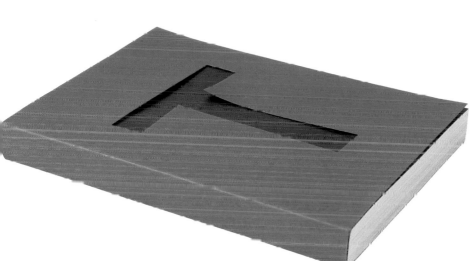

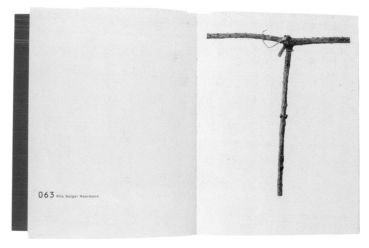

Design: Atelier Roger Pfund
Project: Hundert T Variationen
Author: Jan Teunen
Publisher: Verlag Hermann Schmidt, Mainz
Size: 230 x 170mm (9 x 6⅝in)
Pages: 240
Year: 2000
Country: Germany

Made of wood, with a top-loading slot, this slipcase makes a striking statement on any bookshelf. The project consists of 100 different interpretations of the letter T, beginning with the wooden case itself where the letter is simply printed in black and bleeds off the edges. The rich blue cover bears no title; rather, an upper-case T is die-cut out of it to reveal the black endpapers below.

Design: Intro
Project: The Colour of White
Publisher: thecolourofwhite.com
Size: 263 x 263mm (10⅜ x 10⅜in)
Pages: 78
Year: 2001
Country: United Kingdom

An expensive expanse of nothing. This case-bound, cloth-covered hardback volume has its title embossed into the surface of its front board. Inside, the purity of the white is blinding. The main body of the book has French-folded pages with the names of various artists on each page. At the back, the paper changes from thick silk-coated stock to a heavy white tracing paper, again French-folded but with text screenprinted in white.

The project was created to announce the launch of a new online art gallery. The design company responsible for the piece, Intro, created an impressively loud statement for the gallery by not shouting – indeed, by hardly even whispering. The book was produced as a limited edition and instantly became highly collectable.

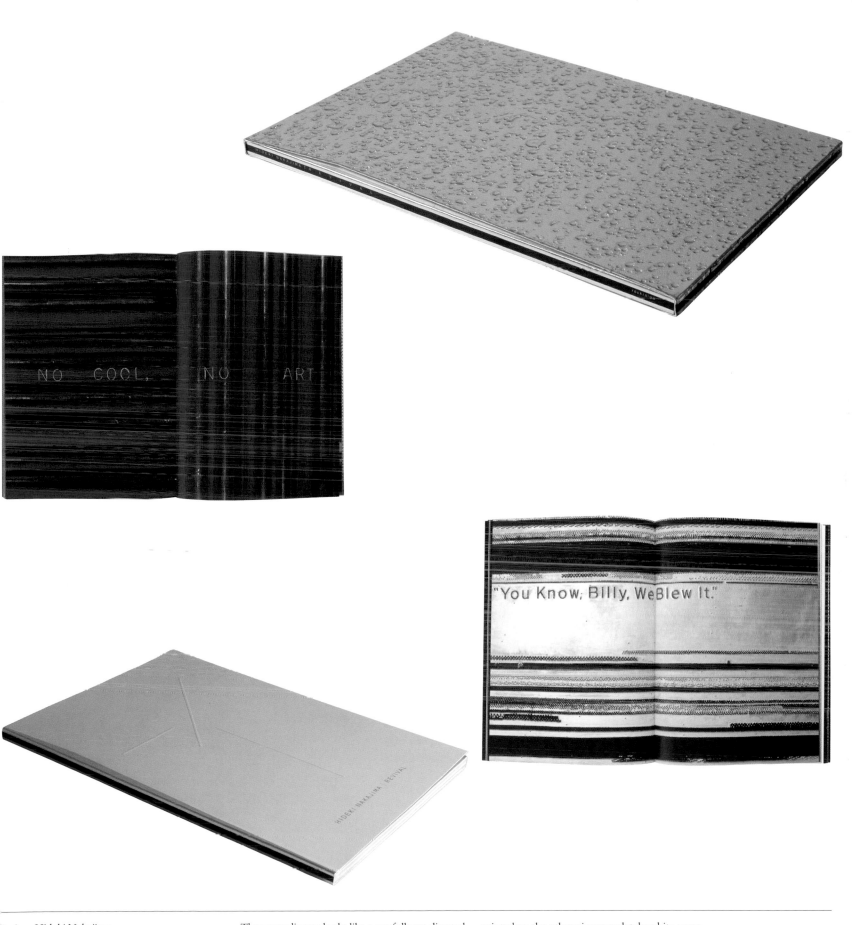

Design: Hideki Nakajima

Project: Revival

Author: Hideki Nakajima

Publisher: Rockin' On

Size: 300 x 216mm (11¾ x 8½in)

Pages: 108

Year: 1999

Country: Japan

The outer slipcase looks like a carefully art-directed still-life photo shoot. The surface of the silver mirrorboard has been magically covered with thousands of small water droplets – impossible but spectacular (in a very minimal manner). The level of detail within every element of this piece is exquisite: the slipcase has a very slight angled recess which allows the book to be removed more easily; the angled shape of this recess is printed on the otherwise completely white cover. The book contains a selection of the typographic/photographic images created by the designer for the Japanese film magazine *Cut*.

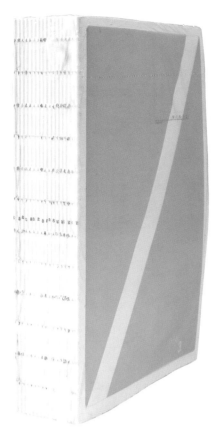

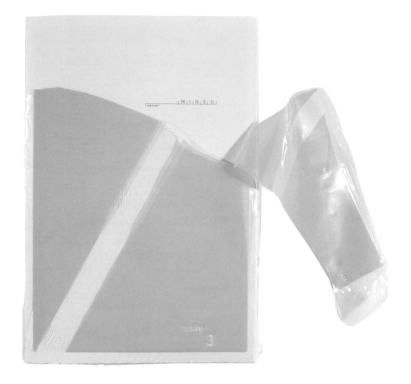

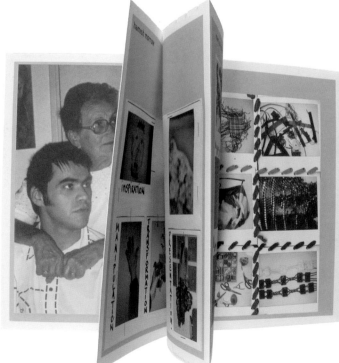

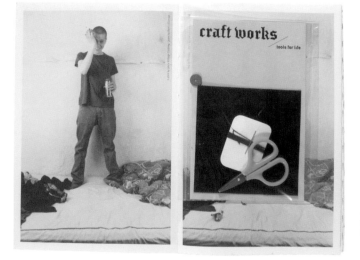

Design: Andreas Laeufer
Project: Mined
Publisher: Tank Publications
Size: 240 x 160mm (9½ x 6¼in)
Pages: 544
Year: 2002
Country: United Kingdom

To open is to destroy. The cover is nothing more than shrinkwrapped polythene – the yellow block on the front is in fact stuck onto the plastic. The book does not seek to hide the industrial techniques used in its production; the binding is raw and exposed. The pages have not been trimmed down, which means would-be viewers require a lot of commitment. Not only do they have to rip off the cover, they then have to tear the pages to see the content. Sandwiched in the middle of this thick volume are 'tools for life' – a pair of scissors and some thread. Are they there to assist with the healing necessary after the many acts of destruction the reader must carry out to access the book itself?

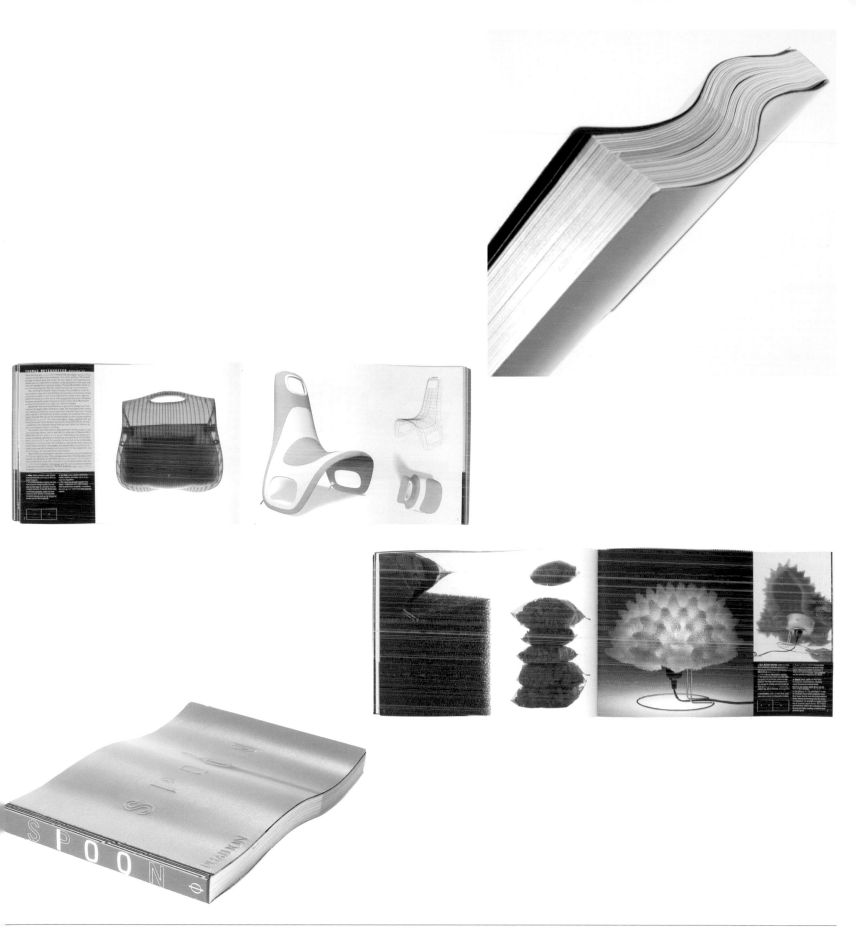

Design: Mark Diaper

Project: Spoon

Publisher: Phaidon

Size: 210 x 300mm (8¼ x 11¾in)

Pages: 448

Year: 2002

Country: Germany

Showcasing the work of 100 product designers, this book is a three-dimensional product in its own right. The front and back covers are carefully machine-bent to form a soft wave shape, based on the contours of a spoon (to reflect the title). The pages of the book are printed on light stock, so they too follow these organic contours. The end result is a very striking object – by its very form, it needs to be set aside from other books on a shelf.

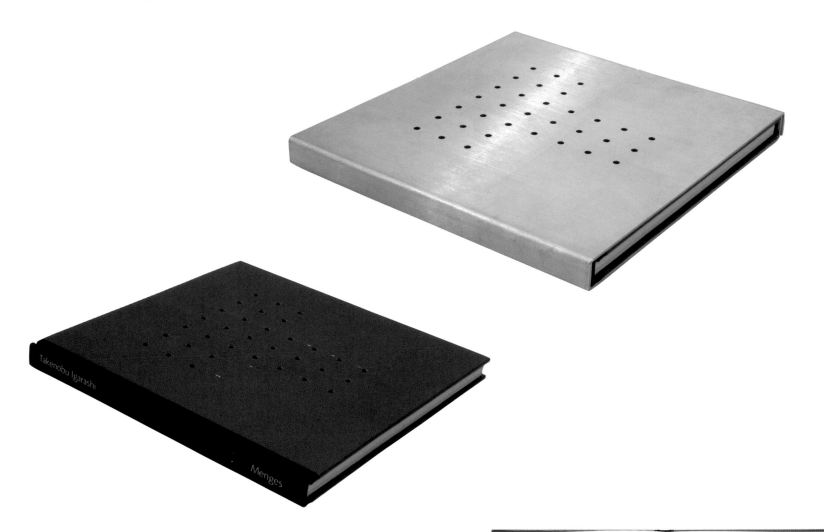

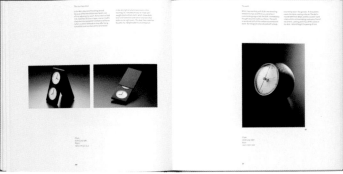

Design: David Quay & Ting Lam Tang

Project: Takenobu Igarashi

Author: Takenobu Igarashi

Publisher: Edition Axel Menges

Size: 247 x 247mm (9¾ x 9¾in)

Pages: 146

Year: 1998

Country: United Kingdom

Encased within two sheets of aluminium, the book echoes the industrial qualities of the designer's work, which ranges from product design to sculpture and graphic design. A series of small holes are drilled in both the front and back panels to form a grid in the shape of the designer's initials. These holes are bored through both the metal casing and the book's cover boards. Inside, the design is clean and pure, giving the work space to speak for itself. Although the packaging is elaborate and distinctive, as a whole the piece doesn't shout for attention.

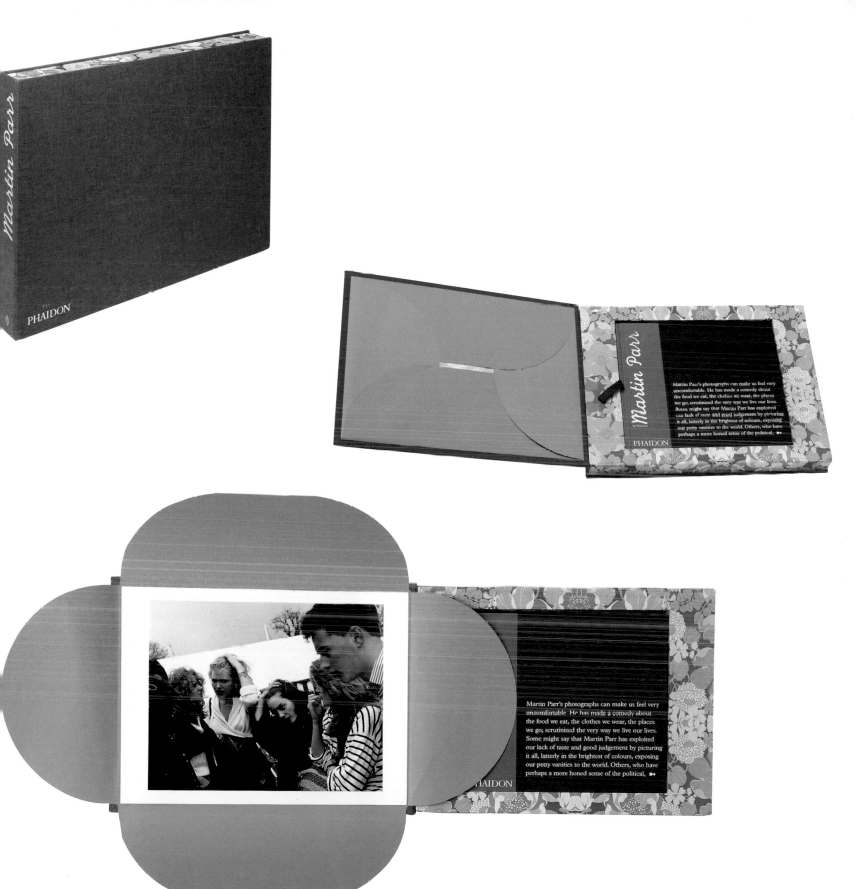

Design: Nick Bell
Project: Martin Parr (Collector's Edition)
Publisher: Phaidon Press
Size: 330 x 430 x 48mm (13 x 17 x 1⅞in)
Pages: 352
Year: 2002
Country: United Kingdom

Produced in standard and limited editions, *Martin Parr* exploits the kitsch qualities typical of the photographer's images of working-class domesticity. The special limited-edition version comes in an elaborate presentation box, with the book enclosed in a 1970s patterned-wallpaper casing. A card envelope on the inside front cover contains an original signed print. The book cover juxtaposes clashing brown leatherette and purple cloth.

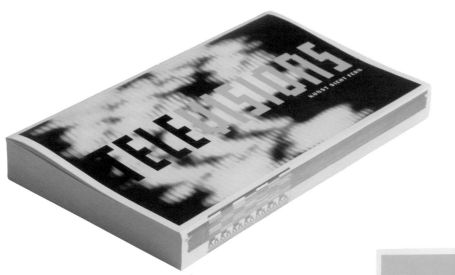

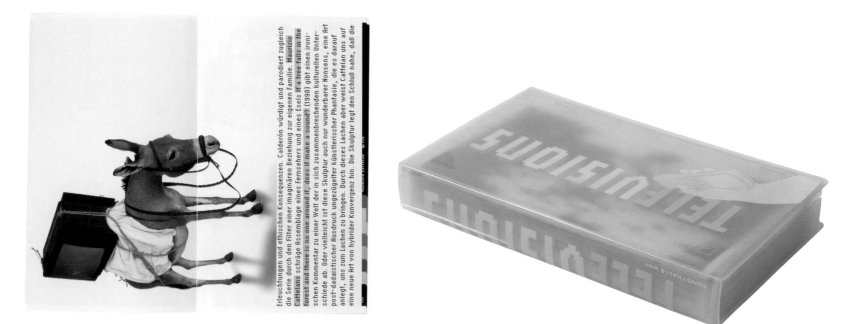

Packaging

028/029

Design: Lichtwitz Leinfellner
Project: Televisions: Kunst Sieht Fern
Publisher: Kunsthalle Wein
Size: 186 x 108mm (7¼ x 4¼in)
Pages: 314
Year: 2001
Country: Austria

A standard VHS video case is appropriated for the outer packaging of this piece. The book itself has the dimensions of a video cassette, which allows it to sit comfortably inside the case. The book is self-covered (that is, the cover is in paper of the same weight as the text pages). A variety of television testcards and teletext-style effects are used throughout, including bitmapped elements that appear on page edges.

engaged multiple — not intended for sale in the sense that a 1960s multiple would be promoted by a gallery or print workshop, began to flourish in the 1990s. Artists evaded or ignored the gallery system — they organised their own exhibitions (Damien Hirst); they functioned as writers (Matthew Higgs, Juan Cruz) and formed bands (Martin Creed, Georgina Starr). And they ran their own 'galleries'. Tracey Emin and Sarah Lucas' 'Shop' (1992) and Sarah Staton's 'SupaStore 93' (1993–8), like Claes Oldenburg's 'The Store' in 1960s New York, championed the handmade and, therefore necessarily, small edition as opposed to the large editions of fabricated multiples published by commercial galleries.

Conventional dichotomies of the artwork/multiple (where the multiple was really a repeated artwork) and the assisted-readymade/multiple began to be questioned: indeed, the notion of the 'artwork' became suspect. Mariele Neudecker's plaster, watercolour and filter-floss Mountain was made in an edition of 7: but to all intents and purposes these are what would have traditionally been called repeated or a series of artworks. The 'readymade' is usually thought of as the opposite of an artist's multiple, imparting the everyday into art whereas the multiple exports the art object into everyday life. But artists such as Mike Nelson Towards a

Fiona Banner

Table Stops
2000
Glazed ceramics, with wooden box
Dimensions as installed
Edition of 100

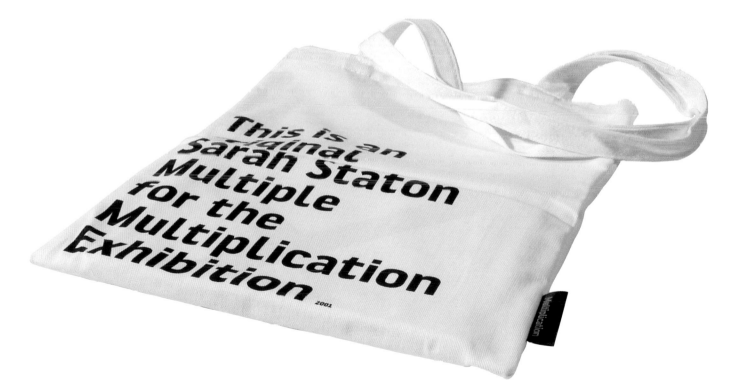

Design: A2-Graphics/SW/HK
Project: Multiplication
Author: Stephen Bury
Publisher: The British Council
Size: 210 x 148mm (8¼ x 5¾in)
Pages: 158
Year: 2001
Country: United Kingdom

The work of one particular artist is revealed even before the catalogue itself becomes visible. To reflect the particular nature of an exhibition about artists' multiples, the artist Sarah Staton created this white drill-cotton shopping bag, one side of which features a drawing by the artist and the other side of which (shown above) introduces the show. Inside, the colour reproductions of the works have been glued in by hand.

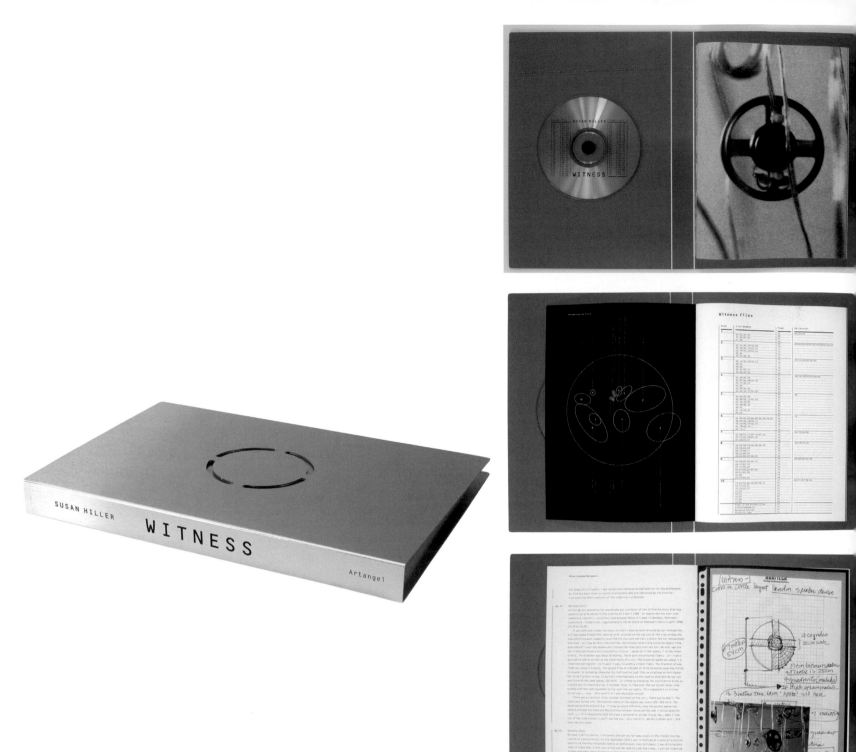

Design: Mark Diaper

Project: Witness

Author: Susan Hiller

Publisher: Artangel

Size: 270 x 185mm (10⅝ x 7¼in)

Pages: 78

Year: 2000

Country: Germany

The sleek, 'other-worldly' quality of its aluminium cover is very appropriate to the contents of this book, which was created to accompany an installation by artist Susan Hiller. *Witness* is about UFO sightings, and the enclosed CD contains recordings of people's accounts of their experiences. The disc is partially revealed through the cover's die-cut slots, which reflect the shape of the small speakers used in the installation.

The pages of the book have an almost scrapbook-like quality in places, with all visual images shown inside clear plastic filing sleeves. A timeline runs down the margins of the text pages, which contain transcriptions of the witnesses' tales.

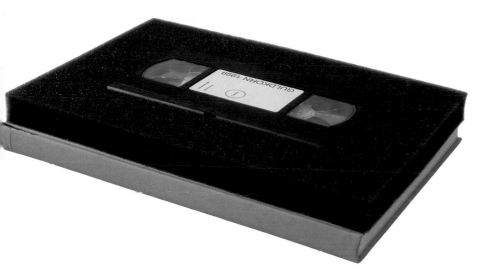

Design: 2GD/2graphicdesign

Project: Creative Circle, Guldkorn 1999

Publisher: Creative Circle

Size: 303 x 213mm (12 x 8⅜in)

Pages: 264

Year: 1999

Country: Denmark

Different elements – an annual and a VHS showreel – are bizarrely combined to produce this work. The cover of this otherwise conventional case-bound book is transformed by the large block of black sponge bonded to its front. A rectangular hole allows the showreel to be inserted; as soon as the book is opened, the video cassette falls out.

Inside, complex typographic effects annotate the introductory pages. The package comes with a set of stickers showing fragments of images. These images are repeated on the divider pagers, with an area left blank where the sticker is to be added.

Surface

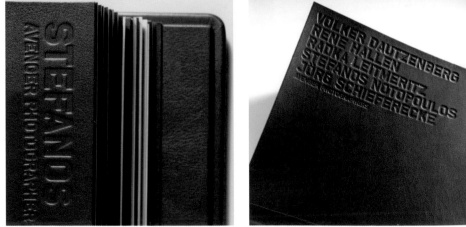

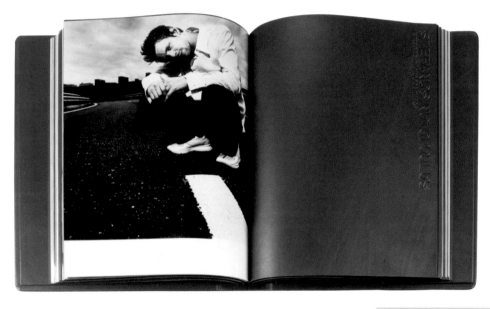

Design: Projekttriangle

Project: Avenger Photographers

Publisher: Avenger Photographers

Size: 380 x 330 x 60mm (15 x 13 x 2⅜in)

Pages: 60

Year: 2002

Country: Germany

Fragments of human forms are embossed into the surface of the cover of this leather-bound photographer's book. The same brown leather is incorporated into the divider pages, where the text is again embossed.

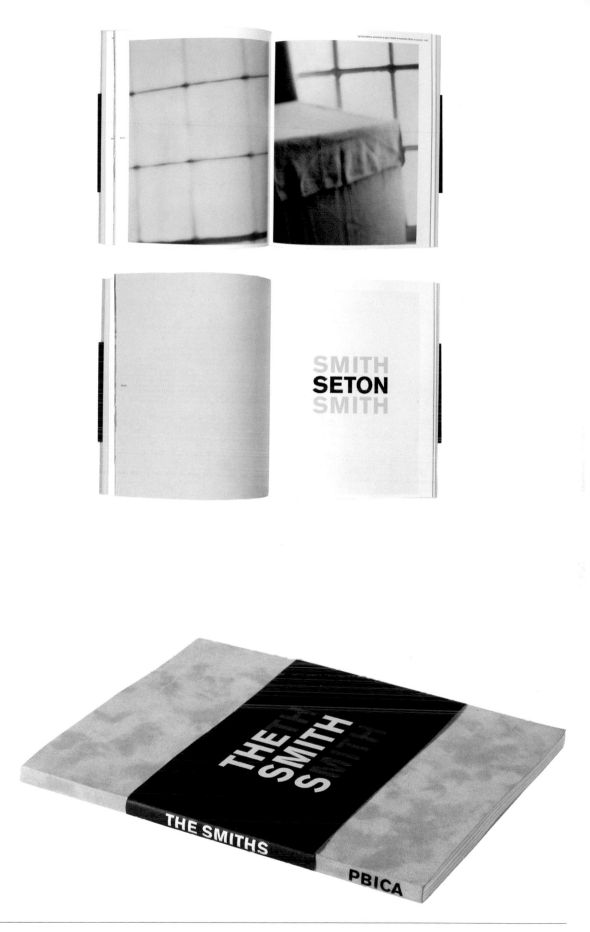

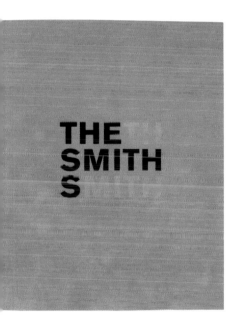

Design: COMA
Project: The Smiths
Publisher: Palm Beach Institute
 of Contemporary Art
Size: 215 x 170mm (8¼ x 6¾in)
Pages: 112
Year: 2002
Country: United States of America/Holland

For this book showing the work of three artists – the renowned modernist Tony Smith and his two daughters Chiara (Kiki) and Seton – the designers developed a typographic pun by repeating the word 'Smith' to illustrate the multiplicity of the family members' name and work. The cover of the book has a flock finish, with the title printed in black and the repeated letters embossed. The position of the title on the cover is reflected on a bellyband that seals the book. The size of the book is based on Seton's work, the typography is based on Tony's work, and the cover material and colour use are based on Kiki's work.

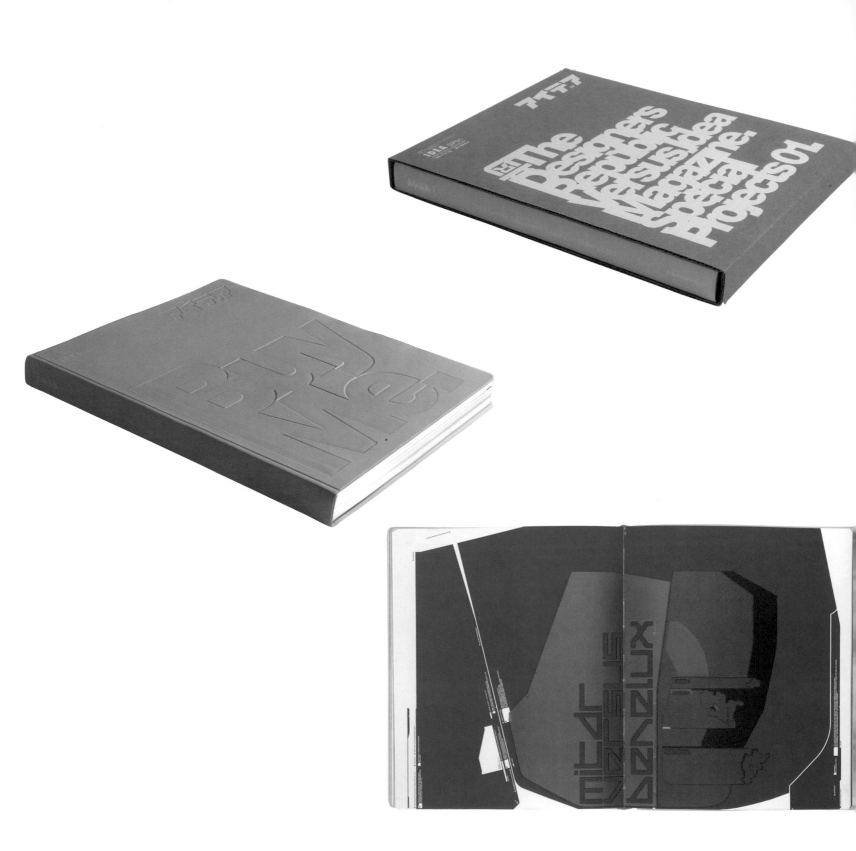

Design: The Designers Republic
Project: The Designers Republic versus Idea
Magazine
Publisher: Seibundo Sinkosha Publishing
Size: 292 x 238mm (11½ x 9⅜in)
Pages: 220
Year: 2002
Country: United Kingdom/Japan

This is a remix book of the work of the Designers Republic produced by the Japanese design journal *Idea*. For the project, the designers have deployed the full arsenal of printed pyrotechnics, using various special inks, metallics and fluorescents. The standard brown carton slipcase is transformed into something precious by the addition of the title silkscreen-printed in white. Beneath this is a cream rubber cover with the words 'Buy Me' embossed into the surface.

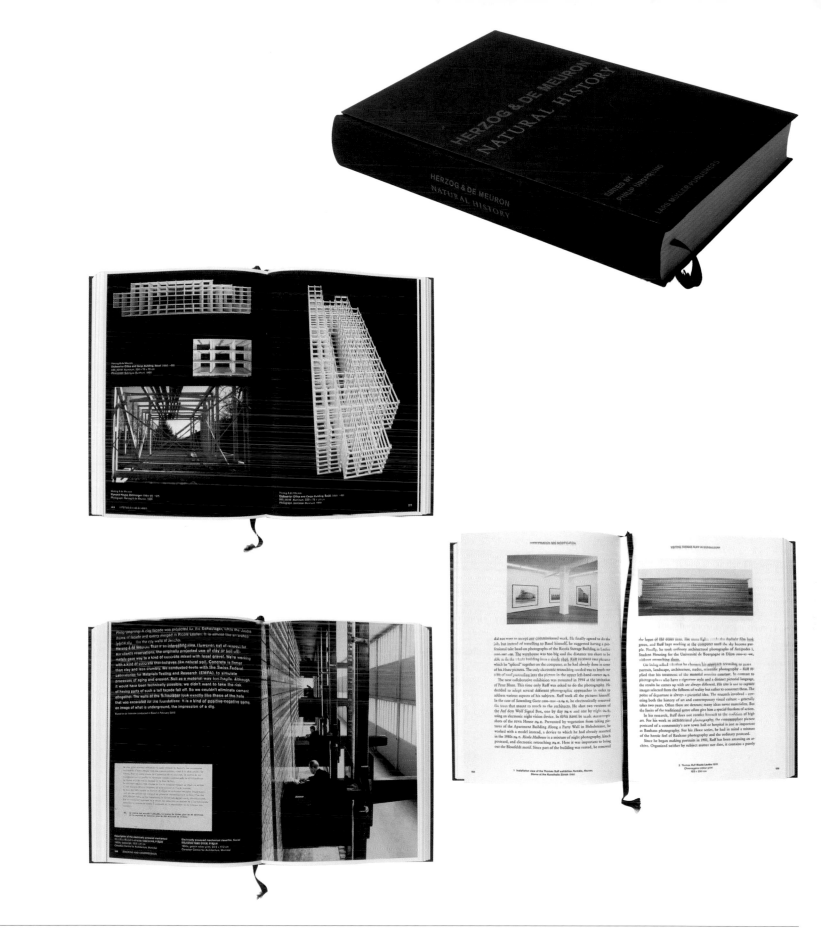

Design: Lars Müller & Hendrik Saulter
Project: Herzog & De Meuron: Natural History
Author: Philip Ursprung
Publisher: Lars Müller Publishers
Size: 245 x 170mm (9⅝ x 6¾in)
Pages: 460
Year: 2002
Country: Switzerland

Produced to accompany a travelling exhibition, *Herzog & De Meuron: Archaeology of the Mind*, organized by the Canadian Centre for Architecture, this book has an austere, timeless quality. On the cover, the effect created by the black cloth spine, matt black boards and muted typography is offset by a series of embossed 3D impressions on both the front and back.

Inside, the book has a traditional academic feel, with most pages printed on a soft, uncoated natural white stock. However, lighter-weight coated sections, printed with a solid black background and a white border, punctuate the project throughout.

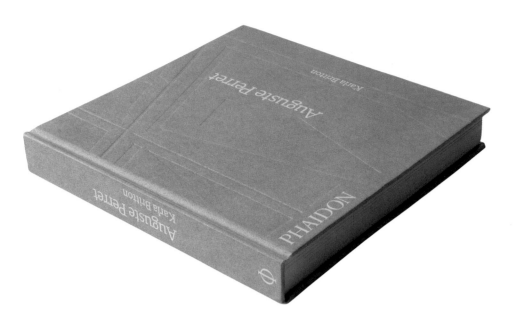

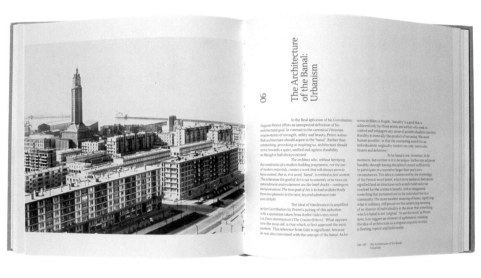

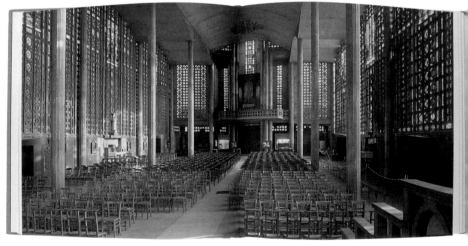

Design: Struktur Design

Project: Auguste Perret

Author: Karla Britton

Publisher: Phaidon Press

Size: 215 x 215mm (8½ x 8½in)

Pages: 256

Year: 2001

Country: United Kingdom

Architect Auguste Perret was a pioneer in the use of reinforced concrete in the Twenties and Thirties. This fact was reflected in the colour and texture of the cover of this Phaidon monograph, for which a concrete pattern used in one of the architect's key works was embossed into the board's surface. Internally the book uses a clean, modern, chiselled serif font, again to reflect the architect's transitional style between classical and modern.

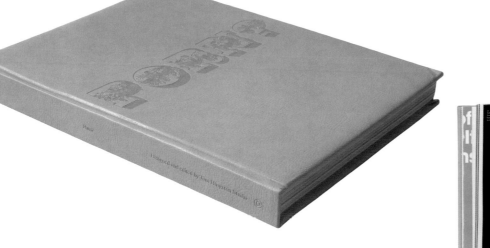

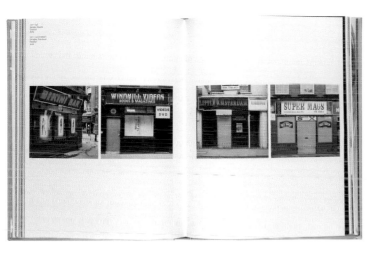

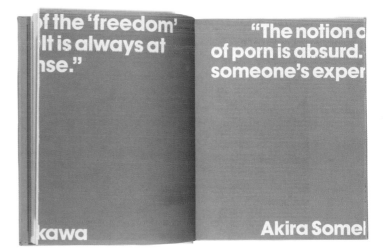

Design: Tom Hingston Studio

Project: Porn?

Editor: Tom Hingston Studio

Publisher: Vision On

Size: 317 x 246mm (12¼ x 9¾in)

Pages: 304

Year: 2002

Country: United Kingdom

Barbie-pink padded leatherette provides a striking cover for this at times sexually explicit book. Set in a highly decorative Victoriana font, the title is embossed into the flesh of the tactile volume. A series of interviews form the introduction, the pages of which are French-folded, with quotations from various photographers printed inside. The text section is followed by a variety of different photographers' interpretations of the term 'porn'. These range from the predictable to the bizarre and abstract.

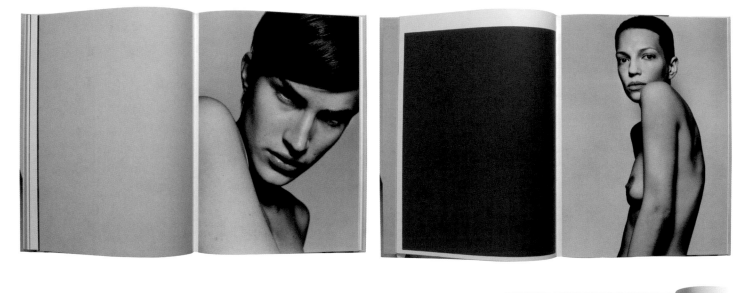

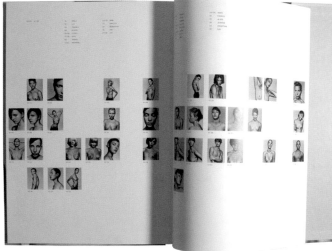

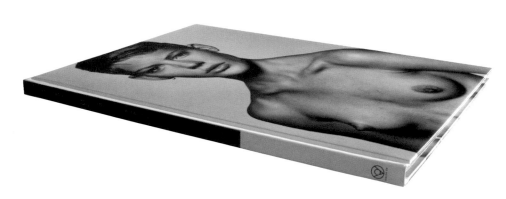

Design: Spin
Project: Rankin/Breeding: XX/XY
Publisher: Vision On
Size: 337 x 247mm (13¼ x 9¾in)
Pages: 64
Year: 2002
Country: United Kingdom

This book presents a photographic exploration of gender ambiguity among the young and fashionable. The cover features a grid of small raised dots of varnish, which create a subtle textured surface and glint in the light against the matt laminated cover – an effect that could be likened to goose bumps. The main pages of the book give no indication of individual models' sex, although flat pale pink and grey are employed throughout to mislead readers. At the end of the book a series of index pages show all the images as thumbnails and finally reveal the gender of the models.

Design: Perndl + Co
Project: Gnadenlos/Franz West/Merciless
Publisher: Hatje Cantz Verlag
Size: 320 x 242mm (12⅝ x 9½in)
Pages: 160
Year: 2001
Country: Austria

The difficulty of finding a representative image to put on the cover of a book about an artist who has produced work in a variety of media is a common one. Here the problem was resolved by not using any images at all, but instead embossing a chicken-wire pattern into the surface of the otherwise typographic cover. Chicken wire was deemed appropriate as the artist uses it in many of his projects, from sculpture to paintings.

Cover

Design: Experimental Jetset
Project: The People's Art
Authors: Bartomeu Marí & Carel Blotkamp
Publisher: Porto 2001
Size: 185 x 127mm (7¼ x 5in)
Pages: 128 + 10 dust jackets
Year: 2001
Country: Holland

This book comes with ten interchangable dust jackets, one by each of the artists featured. This solution sidestepped the issue of having to select one particular artist's work to represent all the others' on the cover – instead everyone has their own. The whole book is secured with a bellyband that gives the title and other information.

The text on the open book pages and dust jackets is largely illegible in the image.

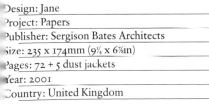

Design: Jane
Project: Papers
Publisher: Sergison Bates Architects
Size: 235 x 174mm (9¼ x 6⅞in)
Pages: 72 + 5 dust jackets
Year: 2001
Country: United Kingdom

It is only when you open this otherwise plain
book that the multiple dust jackets are revealed.
As a play on the title of the book, there is a series
of different-coloured sheets of paper all containing
the same information and all printed in silver.
The colour palette is beautifully muted and relates
to the architects' own preferences.

Packaging

042/043

Design: Büro für Visuelle Gestaltung
Project: Ausgesprochen
Author: Otto Kapfinger
Publisher: Verlag Anton Pustet
Size: 225 x 160mm (8⅞ x 6¼in)
Pages: 128
Year: 1999
Country: Austria

This academic book about architecture by Otto Kapfinger has a beautifully austere quality. The dust jacket shows the author's scribbled notes printed in white on glassine paper. The text inside is set in two muted colours which are alternated.

Design: Hans Bockting (UNA)

Project: 1 + 1 – 3

Author: Atte Gibb

Publisher: (z)oo Productions

Size: 276 x 177mm (10⅞ x 7in)

Pages: 220

Year: 1993

Country: Holland

The title of this work is cleverly illustrated by the cover. The dust jacket is printed on very lightweight paper. On the front is an image of a naked woman; in exactly the same position on the inside of the jacket is a naked man. It has been smeared with oil so that the thin paper has become translucent, thereby joining the male and female images together. On the cover of the bound book is an image of a baby (hence = 3).

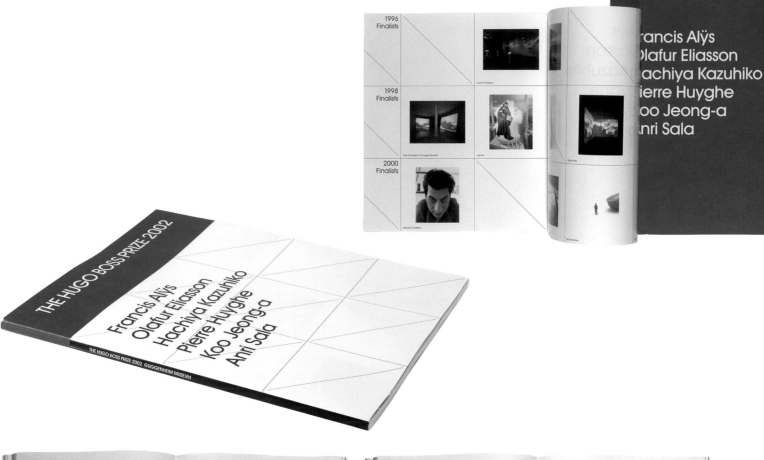

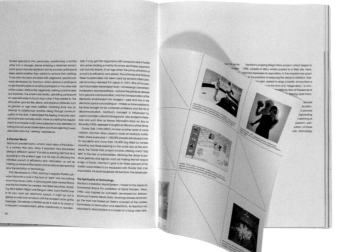

Design: COMA

Project: The Hugo Boss Prize 2002

Publisher: Guggenheim Museum

Size: 342 x 270mm (13½ x 10⅝in)

Pages: 110

Year: 2001

Country: United States of America/Holland

Two different page sizes are used in this art-prize book. The shortlisted artists are named on the cover, while the previous year's winners are given on the inside of the cropped dust jacket. This same cropped page size is cleverly reused inside the book, so that text and images appear on different-sized pages.

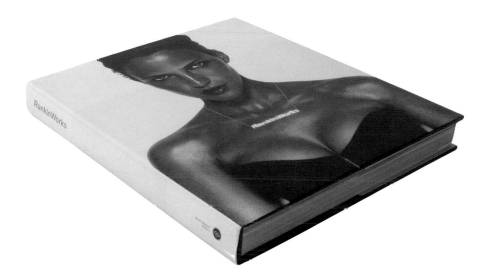

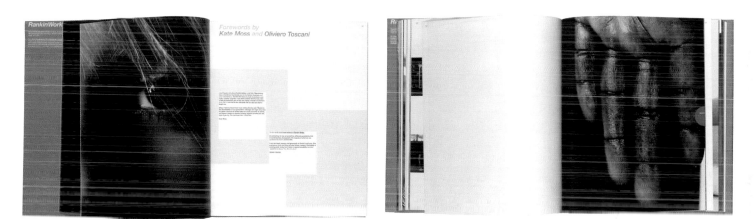

Design: Form

Project: Rankin Works

Editor: Liz Farrelly

Publisher: Booth-Clibborn Editions

Size: 308 x 260mm (12⅛ x 10¼in)

Pages: 320

Year: 2000

Country: United Kingdom

The dust jacket of this hefty photographer's book hides an amusing joke. The title 'Rankin Works' is replaced on the front of the case-bound book with the single word 'Hard' positioned in the same place as on the jacket. This little four-letter word comment is appropriate given the industrious disposition of the photographer.

The book also contains a self-censoring device. A section of the book's pages have been trimmed short and a small sticker used to seal them. The section contains images from a show entitled *Naked*.

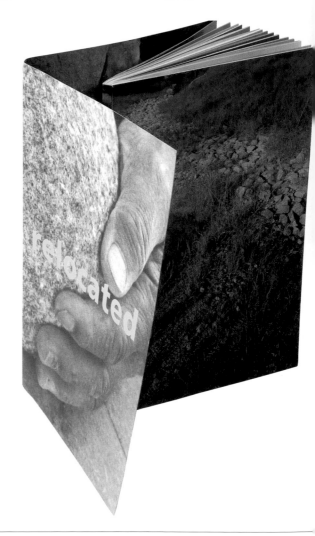

Design: COMA

Project: Relocated: Twenty Sculptures
by Isamu Noguchi from Japan

Publisher: The Isamu Noguchi Foundation Inc.

Size: 275 x 187mm (10⅞ x 7⅜in)

Pages: 56

Year: 2001

Country: United States of America/Holland

The cover of this book wraps around from the back and is printed on a cast-coated board. The matt outside shows a black and white detail of an image of the artist at work on one of his sculptures, while the gloss inside features a series of lush green images taken by the artist to illustrate his connection with nature and the elements. The rest of the book is understated, predominantly monochrome in presentation, with olive-green used throughout for section dividers and headings.

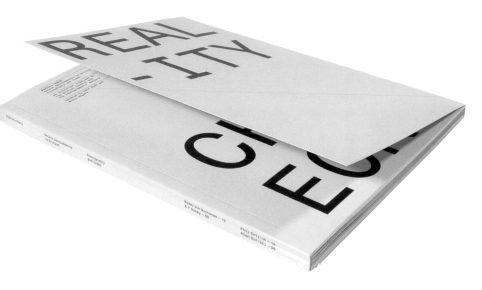

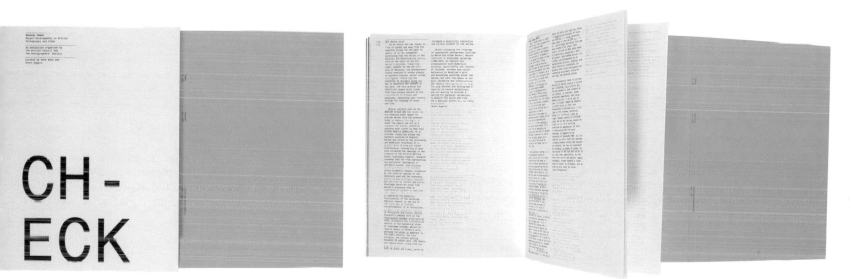

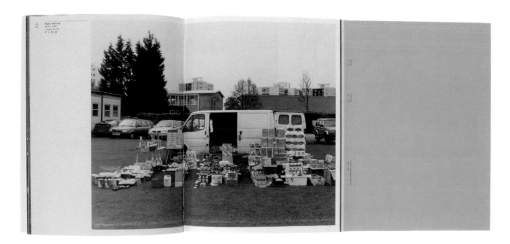

Design: Spin
Project: Reality Check
Authors: Kate Bush & Brett Rogers
Publisher: The British Council
Size: 225 x 170mm (8⅞ x 6¼in)
Pages: 128
Year: 2002
Country: United Kingdom

An extended back cover wraps around and finishes on the front cover of this photography project. The outside of the closed book is in brilliant high-gloss white, but as you lift the cover an almost radioactive green floods out from the inside of the flap. The same green is used throughout for both typography and secondary images, while the main photography is reproduced in full colour.

Design: Base Design
Project: Air Liquide, Eau Gazeuse
Publisher: Cimaise et Portique.
　　　Centre Départemental d'Art Contemporain
Size: 220 x 220mm (8⅝ x 8⅝in)
Pages: 56
Year: 2002
Country: Spain

This catalogue was produced for an exhibition of work by Sophie Wethnall and Grout/Mazéas at the Cimaise et Portique art gallery in Spain.

The cover takes the form of a triptych printed in four spot colours. The raised title is printed using thermography and is similar in appearance to braille.

Inside, the artists' work is differentiated by giving Wethnall's pages white borders while Grout/Mazéas's photographs are printed full-bleed.

esign: Base Design
oject: Impacte Gaudí
blisher: Centre Santa Mónica.
 Generalitat de Catalunya
ze: 297 x 210mm (11⅝ x 8¼in)
ges: 212
ar: 2002
untry: Spain

This catalogue was published to accompany an exhibition presented by the Generalitat de Catalunya as a contribution to the anniversary celebrations in honour of Antoni Gaudí. It shows the work of different artists who have been influenced by the Spanish architect.

There is no fixed grid for the catalogue; it changes for each artist profiled, thereby creating a dynamic rhythm. The front cover extends around the whole book. On the outside it is uncoated, whereas the inside is laminated. The letter G has been die-cut into the cover, allowing fragments of the photographs beneath to be spied from the outside.

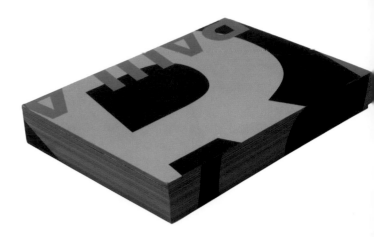

Image

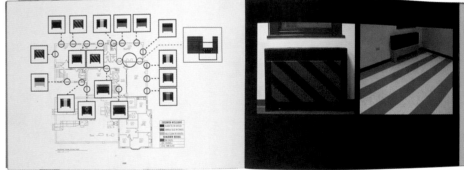

Design: Paula Scher/Pentagram
Project: Make It Bigger
Author: Paula Scher
Publisher: Princeton Architectural Press
Size: 165 x 235mm (6½ x 9¼in)
Pages: 272
Year: 2002
Country: United States of America

As a graphic illustration of the title of this book, designed by and about the work of Paula Scher, Scher's name extends beyond the boundaries of the trimmed cover boards and bleeds around onto the edges of the book block. The boards have been trimmed flush with the text pages so that the whole book takes on the appearance of a solid mass.

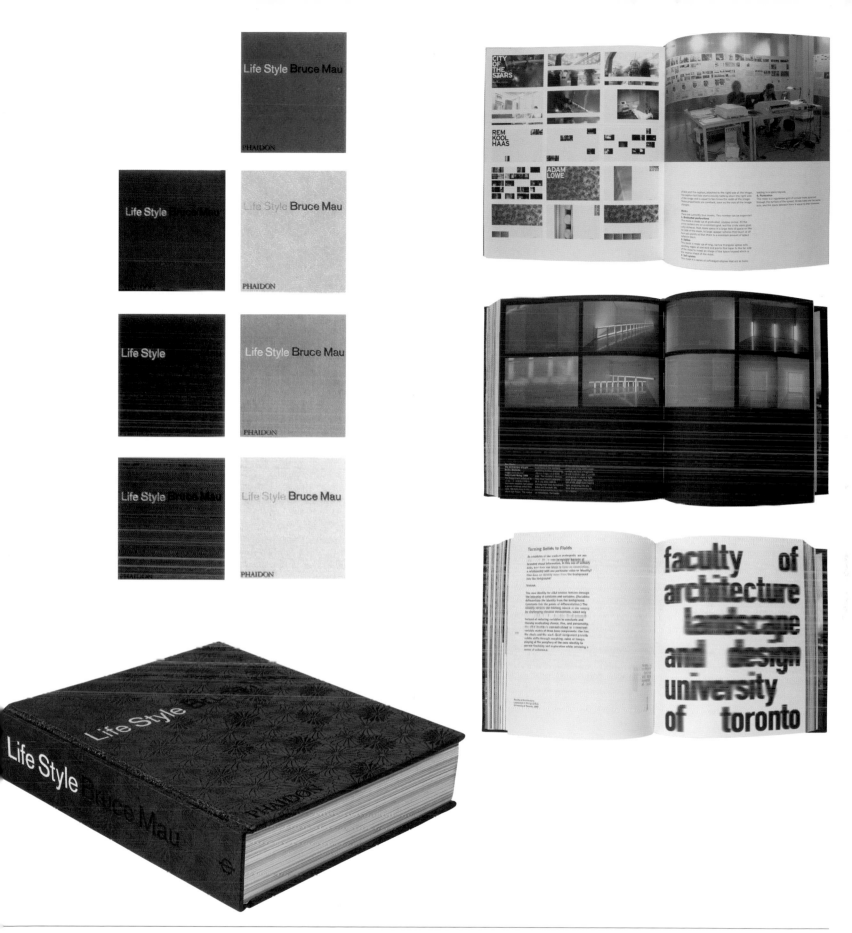

Design: Bruce Mau
Project: Life Style
Author: Bruce Mau
Publisher: Phaidon Press
Size: 252 x 216mm (10 x 8½in)
Pages: 626
Year: 2000
Country: Canada

The purchaser is faced with the difficult decision of deciding which cover to choose: eight different cloths have been used, in a range of shades from subtle to ones of tandooricsque vibrancy. The typography remains constant across all versions, however, the utilitarian text-setting contrasting with the varied covers. The book is a little reminiscent of Mau's *S, M, L, XL* (see page 182), taking the form of a kind of visual stream of consciousness, with little regard for conventional book structure.

Design: J. Abbott Miller/Pentagram

Project: John Kelly

Publisher: 2wice Arts Foundation

Size: 260 x 210mm (10¼ x 8¼in)

Pages: 152

Year: 2000

Country: United States of America

The lenticular cover portrait of this book – about the work of dancer/choreographer John Kelly – morphs between showing the artist as a man and as a woman, thereby suggesting visually the complex nature of his work.

The clean typographic design is offset by the use of sinuous brackets around areas of text, which gives the work a retro 'showbiz' quality. Layered sheets of tracing paper can be peeled away to reveal and obscure different details.

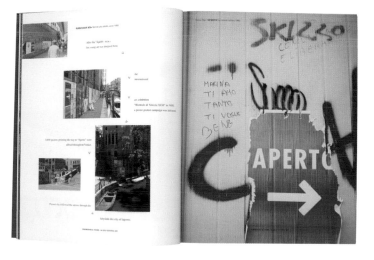

Design: Christoph Steinegger/Sabotage

Projects: Das Medien Mysterien Theater +
 Sabotage: Torments & Vices

Publisher: Edition Selene/Gestalten Verlag

Size: 250 x 195mm (9⅞ x 7¾in)

Pages: 234 + 182

Year: 2002

Country: Austria/Germany

To coincide with the tenth anniversary of Sabotage Communications, the Viennese music label launched these two books. *Das Medien Mysterien Theater* documents the company's international media activities in the form of reviews, press cuttings and articles. The second book, *Sabotage: Torments & Vices*, visually illustrates all record releases, artist editions, multiples and events.

Both books have covers that are facsimiles of cloth-covered case-bound volumes, but which are in reality just photographic reproductions on card – a little trick that perfectly illustrates the playful nature of this design company.

CONVERSACIONES CON FOTÓGRAFOS

Miguel
Rio Branco
habla
con Tereza
Siza

CONVERSACIONES CON FOTÓGRAFOS

Duane
Michals
habla
con Enrica
Viganò

CONVERSACIONES CON FOTÓGRAFOS

Joan
Fontcuberta
habla
con Cristina
Zelich

CONVERSACIONES CON FOTÓGRAFOS

Bernard
Plossu
habla
con Juan Manuel
Bonet

CONVERSACIONES CON FOTÓGRAFOS

Alberto
García-Alix
habla
con Mireia
Sentís
y José Luis
Gallero

CONVERSACIONES CON FOTÓGRAFOS

Max Pam
habla
con Pablo Ortiz
Monasterio

Packaging

054/055

Design: Fernando Gutiérrez/Pentagram
Project: Conversaciones con Fotógrafos
Publisher: La Fábrica/Fundación Telefonica/
 Photo España
Size: 145 x 105mm (5¾ x 4⅛in)
Year: 2001–2
Country: United Kingdom

Conversaciones con Fotógrafos is a series of
pocket-sized books featuring, as the title suggests,
interviews with leading photographers. The cover
of each is in a different colour, taken from a
palette of earthy hues. The large inverted commas
suggest quoted speech and therefore the
conversational nature of the books' contents.

La Confesión de Agustín
JEAN-FRANÇOIS LYOTARD

Cielos de espanto
ALDO ZARGANI

LOSADA

Cuentos completos
ROBERTO ARLT

La cuestión humana
FRANÇOIS EMMANUEL

LOSADA

Design: Fernando Gutiérrez/Pentagram
Project: Identity and book-cover style
Publisher: Losada
Size: 230 x 150mm/200 x 130mm
 (9 x 6in//7⁄8 x 5⅛in)
Year: 2002 (ongoing)
Country: United Kingdom

Creating a new identity for the Spanish publishers
Losada included a complete redesign of the
company's back catalogue. Marion Deuchars was
commissioned to create the illustrations for the
covers, which successfully combine a vibrant
palette of colours with the understated typography
of Pentagram's Fernando Gutiérrez.

Design: Angus Hyland/Pentagram
Project: The Pocket Canons
Publisher: Canongate Books
Size: 145 x 105mm (5¾ x 4⅛in)
Year: 1997
Country: United Kingdom

The Pocket Canons are individual, small-format editions of the books of the King James Bible, with introductions by popular figures from the world of contemporary culture. Pentagram approach the series as though they were designing covers for modern fiction. All the covers use strong black and white images and the same clean sans-serif typography.

Design: Doyle Partners
Project: The Stories of Vladimir Nabokov
Author: Vladimir Nabokov
Publisher: Knopf
Size: 242 x 165mm (9¼ x 6½in)
Pages: 660
Year: 1995
Country: United States of America

Design: Doyle Partners
Project: The Book of Lamentations
Author: Rosario Castellanos
Publisher: Marsilio
Size: 222 x 147mm (8¾ x 5¾in)
Pages: 400
Year: 1996
Country: United States of America

The ghost-like specimen-mounted main title on the cover of *The Stories of Vladimir Nabokov* is almost too pale to make out – you're forced instead to read between the lines and find a meaning in the shadows, an appropriate visual analogy for the experience of reading Nabokov. The simple typographic cover of *The Book of Lamentations* has been turned into a shroud, evocative of the lyrical and mystical nature of the book's contents.

Navigation

When potential readers first pick a book up, they usually begin by flicking through its pages to get some sense of the way in which it is organized. This chapter shows a selection of navigational systems that enable the designer to guide the reader through the often complex levels of information embedded in a book's structure.

Interview: Nijhof & Lee, booksellers

'We get deliveries twice a week, on Tuesdays and Fridays,' explains Warren Lee. 'And then it's like Christmas. Always.' Both Lee and his business partner, Frank Nijhof, obviously still get a huge buzz out of what they do. 'I hope I keep this curiosity,' adds Nijhof. 'Because if I ever lose it, I'll have to quit…'

Any designer with a passion for printed matter who has found him- or herself in Amsterdam will have made the pilgrimage to Nijhof & Lee. This corner bookstore, situated on Staalstraat, in one of the most picturesque areas of the city near the Waterloo fleamarket, has achieved almost mythical status among the international design community. The reality behind the legend does not disappoint – it's not huge, but the store is packed floor to ceiling with goodies. As well as books on art, design and photography on the ground floor, there are antiquarian books on the first floor and a growing collection of tempting Dutch posters on the second floor. The shop has the relaxed atmosphere of a cosy (if somewhat scholarly) living room. Ask anyone who's been there and they will tell you that time seems to pass very quickly at Nijhof & Lee.

Frank Nijhof – the more softly spoken of the two – was born into a family that was already heavily involved in the world of books: his father and grandfather owned a bookshop and a stationery shop. He followed in their footsteps, working for Amsterdam's specialist art bookshop, Premsela, for 17 years. Lee studied history and archaeology in the United States before working at the publishing firm (and antiquarian bookstore) Schors on his arrival in the Netherlands in 1970. With a particular interest in fine art, he then set up his own antiquarian bookstore in the city. Together the pair established Nijhof & Lee in Staalstraat in 1989. Despite their success, there are no plans to move or expand: 'This is where we started and this is where we will stay,' laughs Lee. 'We don't intend to move, we're very happy here. We're very content to work at the scale we work at. I think that if we expanded, we would lose touch with our customers.'

Both Nijhof and Lee are still very hands-on. Most days they can be found working in the shop with their assistant John Fournier, chatting and laughing with the customers, swapping ideas and generally having a good time. 'Quite often, within two or three times of meeting each other, we're on first-name terms with our customers. Sometimes,' Lee adds, 'the first time.'

The pair have a loyal and varied customer base: 'From the student to the retired book lover. We have bibliophiles, a large number of customers from the design world, professional people, artists, people who teach…' These customers are a great source of information. 'We learn so much from our customers,' explains Lee. 'Most important information comes from them – they're our inspiration.' Although Amsterdam is a city filled with bookshops, Nijhof & Lee is the only shop that caters specifically for the design community.

The shop also stocks a fascinating collection of artists' multiples – limited-edition books and pieces that are made as art objects. Many of these first find their way into the shop via customers, and many are student graduation projects – the pair are keen to promote new talent and every year choose a student to make an installation in one of the bookshop's windows. They obviously enjoy the quirky nature of these pieces. 'There is a market for them,' explains Lee, 'It's a small market but it is a fun market, because the people who buy them are really fanatics.' One example is the much-sought-after diary produced by the Dutch design group UNA. A handful of copies are always on sale in the shop in the run-up to Christmas.

Many customers keep in touch via the Nijhof & Lee website, which Lee takes care of. He has tried to maintain the personal touch that is so important to the shop's success: 'The website is an extension of the shop itself. We approach it in a very personal way. The web was developed as something that is very impersonal, but you can be right next to your customer if you know his wants, his needs and his desires. You can serve him through the net just as you can in the shop.'

The last few years have seen an amazing increase in the number of books being published on design – a fact that has not impressed the pair. 'Recently there's been a huge production of design books – it's been an over-production,' says Lee. He can think of five or six publishers whose output is particularly lacklustre: 'They're not really interested in quality, they're only interested in meeting their production schedule.' He also notes the way that many design consultancies now publish books to promote themselves: 'You've always had books made by design companies to advertise themselves, but it used to be after 50 years – now it's after five or ten years.' Maintaining the quality of the books that they have on their shelves is paramount: 'We stock everything that we think is important,' states Lee. 'That doesn't mean that we think that every book we have is beautiful, a fine piece of graphic design. But the book has to have a certain merit or we will not stock it.'

So, what has been their most requested book over the last couple of years? No prizes for guessing which book they have a waiting list for and for which they get at least two or three enquiries a week – it's Wim Crouwel's *Mode en Module*, published by Uitgeverij 010 in 1997. Never reprinted and with an original print run of just 2,500, it's as rare as rocking-horse shit. If you ever see a copy, buy it immediately.

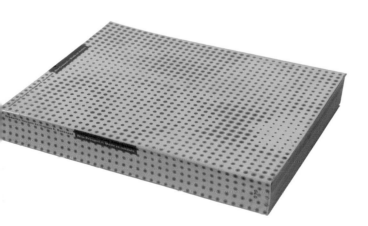

project: Wim Crouwel – Mode en Module
see page 83

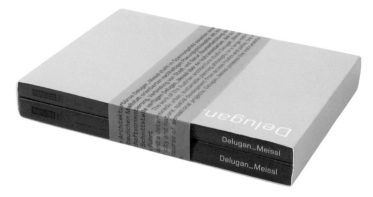

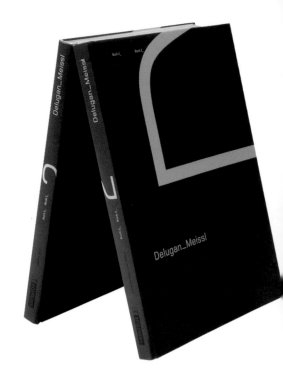

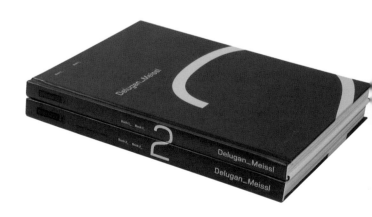

Design: Bohatsch Graphic Design
Project: Delugan_Meissl 2
Authors: Robert Temel & Lisbeth Waechter-Böhm
Publisher: Birkhäuser
Size: 227 x 164mm (9 x 6½in)
Pages: 156 + 184
Year: 2001
Country: Austria

The binding system for this book about an Austrian architectural practice neatly links two separate case-bound books together. One volume concerns concepts, the other documents realized buildings; the clever binding enables the reader to cross-reference the two with regard to particular projects.

The double-hinged cover provides great flexibility: each book can be read conventionally, independently of the other. However, at certain points the spreads in the different volumes work together and images bleed from one to the other (shown above right). The books come housed together in an open-ended slipcase, sealed with a yellow tracing-paper bellyband wrap.

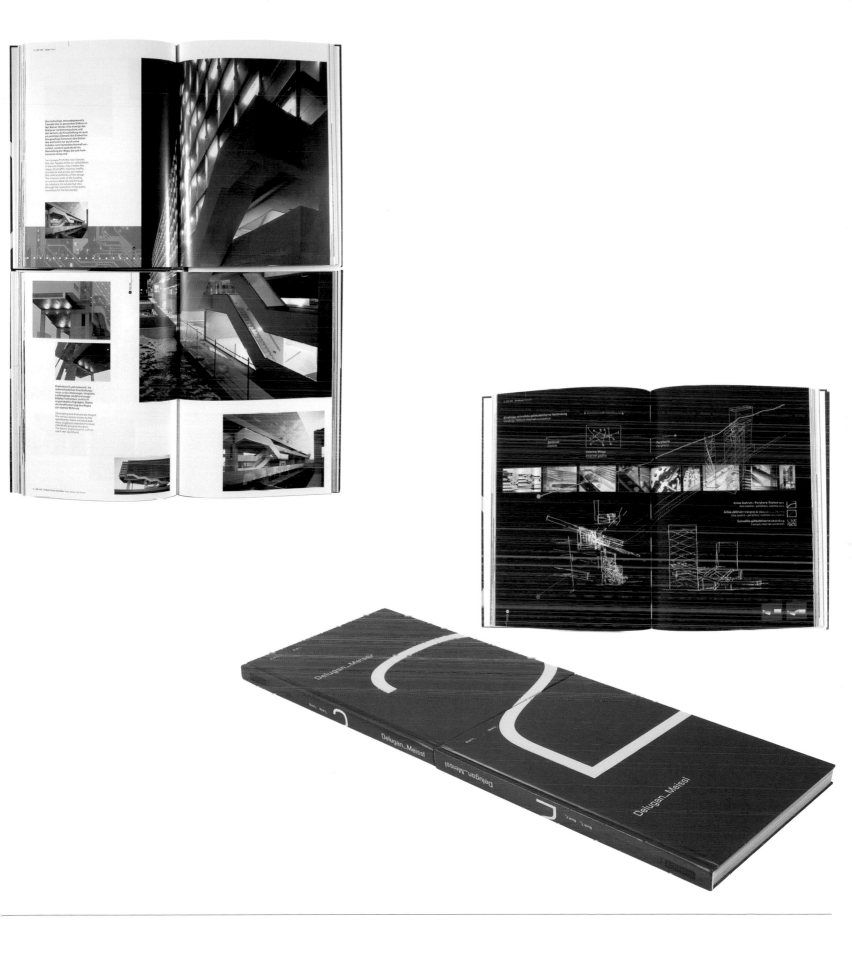

Design: Atelier Works
Project: The Mennonites
Author: Larry Towell
Publisher: Phaidon Press
Size: 266 x 195mm (10½ x 7¾in)
Pages: 292
Year: 2000
Country: United Kingdom

Magnum photographer Larry Towell spent ten years documenting Mennonite communities in rural Ontario and Mexico. This book comprises the photographer's thoughts and images. Text and pictures are kept separate: the words are printed on bible-paper sections interspersed between the coated image sections. The bible paper is also trimmed 4mm (⅛in) short on the fore-edge to further distinguish text from image sections. The image pages are devoid of all typography – there aren't even any folios. Captions and credits are given at the back of the book; identification is assisted by small thumbnail reproductions of all the image spreads. This special edition of the book extends the spartan quality of the interior to the cover, which is in plain high-quality black cloth. The title only appears on the spine in a clear foil blocking.

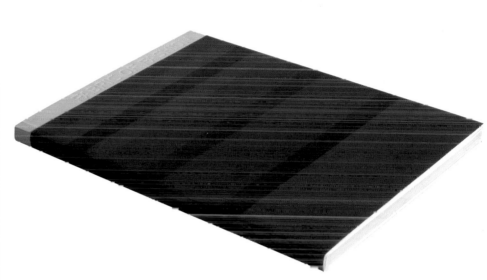

Design: A2-Graphics/SW/HK

Project: Fabric of Fashion

Author: Brett Rogers

Publisher: The British Council

Size: 226 x 167mm (8⅞ x 6⅝in)

Pages: 120

Year: 2000

Country: United Kingdom

Produced for a group show at the Crafts Council in London, this book features French folds and divider pages at the start of each section that are left blank except for the name of the featured designer, which is embossed into the paper surface. Designers' biographies are assembled at the back alongside miniature reproductions of their pages from the main body of the book.

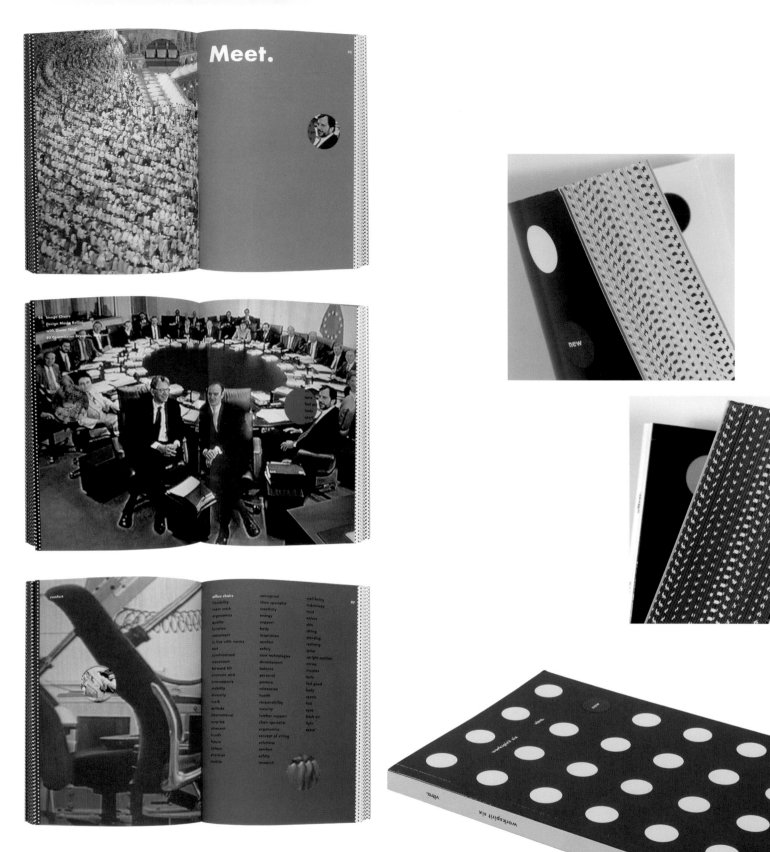

Design: Irma Boom
Project: Workspirit Six
Publisher: Vitra
Size: 235 x 170mm (9¼ x 6¾in)
Pages: 176
Year: 1998
Country: Holland

Produced for the furniture company Vitra, this is somewhere between an artist's book and a catalogue. Printed on cast-coated paper, the spreads switch between using high-gloss and uncoated surfaces. Pages of circular die-cut holes are strategically placed throughout the book: these allow fragments of the following pages to show through and give a glimpse of the underlying contrasting paper surfaces.

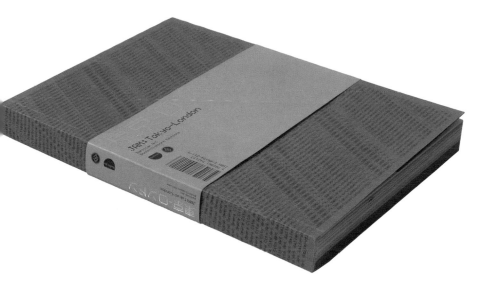

esign: Made Thought

oject: JAM: Tokyo-London

ublisher: Booth-Clibborn Editions

ze: 220 x 160mm (8⅝ x 6¼in)

ges: 352

ear: 2001

ountry: United Kingdom

Default dot-matrix typography repeats the same information in diagonal stripes across the pages of this book about youth cultures in London and Japan. The effect replicates computer scripting programmes and gives this varied collection of work overall unity. The back section of the book, which is printed on a rough craft stock, contains interviews and again repeats strands of type printed in fluorescent pink and black.

Design: COMA
Project: Glee: Painting Now
Publisher: Aldrich Museum of Contemporary Art/
 Palm Beach Institute of Contemporary Art
Size: 166 x 124mm (6½ x 4⅞in)
Pages: 66 + 40
Year: 2000
Country: United States of America/Holland

Produced for a group show, from the outside this looks like a conventional case-bound book. However, once the bellyband has been removed and the cover opened, perceptions quickly change. The book is divided into two parts: the left-hand side comprises a series of postcard images, while the right constitutes a more conventional book.

A series of grey tabs aid navigation in locating works by a particular artist – artists' names are highlighted in magenta on the appropriate pages. The same tab device is also used for the contents list at the front of the postcard section.

Design: COMA
Project: Peter Halley: Maintain Speed
Publisher: D.A.P./Distributed Art Publishers
Size: 255 x 217mm (10 x 8½in)
Pages: 226
Year: 2000
Country: United States of America/Holland

The design of this book about multidisciplinary artist Peter Halley is the result of a very close working relationship between Halley and the design company COMA. Readers are led around the book and the different kinds of exhibition spaces implied by the design and the works themselves. They walk from room to room of installations, approach a painting up close and then retire again. A complex navigation bar runs across the foot of the pages, carrying an assortment of caption details, thoughts and quotations. Towards the back of the book, a series of thumbnail reproductions are connected by threadlike lines to people and texts. This network indicates where items can be found within the book and how works of art relate to each other across time.

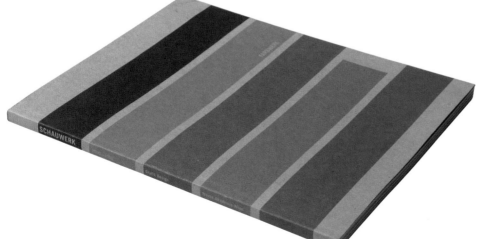

Design: Dechant

Project: Schauwerk

Publisher: Werbe Akademie

Size: 228 x 191mm (9 x 7½in)

Pages: 138

Year: 2002

Country: Austria

Schauwerk, the annual publication of Vienna's Werbe Akademie, features the work of selected students. A 'usual suspects'-style line-up photograph of all the students runs across the inside front and back of the cover. The book is broken into five colour-coded sections, each with a tab bar that appears on every page. These tabs are extruded across the cover to form a series of muted colour panels. Each section of the book is printed on a different paper stock, ranging from coarse uncoated grey pulp to smooth coated gloss high white.

THIS PUBLICATION IS NOT AVAILABLE TO BUY ON CD-ROM/DVD. DISC [INTERACTION REQUIRED]

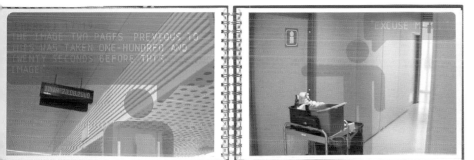

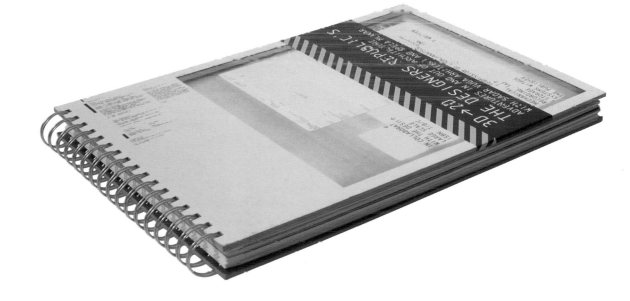

Design: The Designers Republic

Project: 3D-2D Adventures In and Out of Architecture

Author: Spela Mlakar

Publisher: Laurence King Publishing

Size: 230 x 340mm (9 x 13⅜in)

Pages: 198

Year: 2000

Country: United Kingdom

At the outset of this work, the reader is told that interaction is required. However, there is no accompanying CD-ROM or DVD. The Designers Republic produced this book as a record of the signage system they developed for Sadar Vuga Arhitekti's Chamber of Commerce and Industry of Slovenia building. Typically, the book is more of a remix than a straightforward architectural tome. It is heavily laden with computer-speak instructions for reader navigation and information about its production, detailing the formats, colours and software used in the creation of each page. Photographs of the building have been cut up and reassembled into abstract sculptures. Captions have been blown up and overprinted on images, while essays about the architecture have been reduced to 5pt and are consequently lost in the general information overload.

Design: Mark Diaper
Project: Panorama 2
Publisher: Le Fresnoy, Studio National des Arts
 Contemporains
Size: 275 x 205mm (10⅞ x 8in)
Pages: 112
Year: 2001
Country: Germany

Panorama 2 was an exhibition of pieces by 45 artists working at the Le Fresnoy studios. Instead of using page numbers, the accompanying book starts at 0° and ends at 360°, with each artist being assigned his or her own degree. This numbering system is shown on the contents page as a full circle made out of the artists' names.

The introductory essays also feature circular forms. Each spread has a page of text set opposite a page on which a series of small circles perfectly simulate the line breaks and colouring of the facing text page.

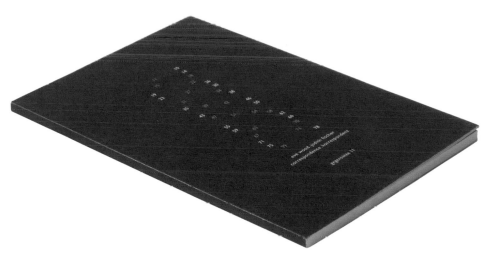

Design: Richard Ferkl

Project: Correspondence

Authors: Eve Wood & Judith Fischer

Publisher: Gegensätze

Size: 185 x 133mm (7¼ x 5¼in)

Pages: 88

Year: 1999

Country: Austria

Two poets each wrote nine poems, which have been arranged to face one another. Poems by Eve Wood always occupy left-hand pages (even page numbers), those by Judith Fischer are set on right-hand pages (odd numbers). After each spread of poems, an almost blank spread follows, on which only the poems' titles appear.

Folios are positioned near the gutter. At the start of the book, a complete set of the page numbers is arranged in a helix-like structure. This is repeated throughout, but the helix progressively moves up and off the page, so that when you reach the pages featuring the last poems, only one set of numbers is left visible.

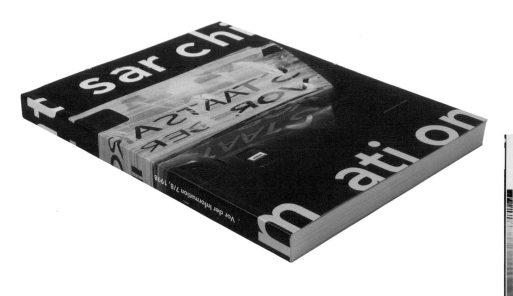

Design: Richard Ferkl & Jane Heiss
Project: State Architecture: Before Information
Publisher: Vor der Information
Size: 307 x 232mm (12 x 9⅛in)
Pages: 350
Year: 1998
Country: Austria

Instead of conventional typographic headlines, this book about the politics of state architecture uses photographs of the chapter titles drawn directly in the environment – on pavement, chairs, cups, TVs etc. The typography playfully moves around the page, to align either with the top or bottom margins of the grid, with footnotes protruding beyond the column width.

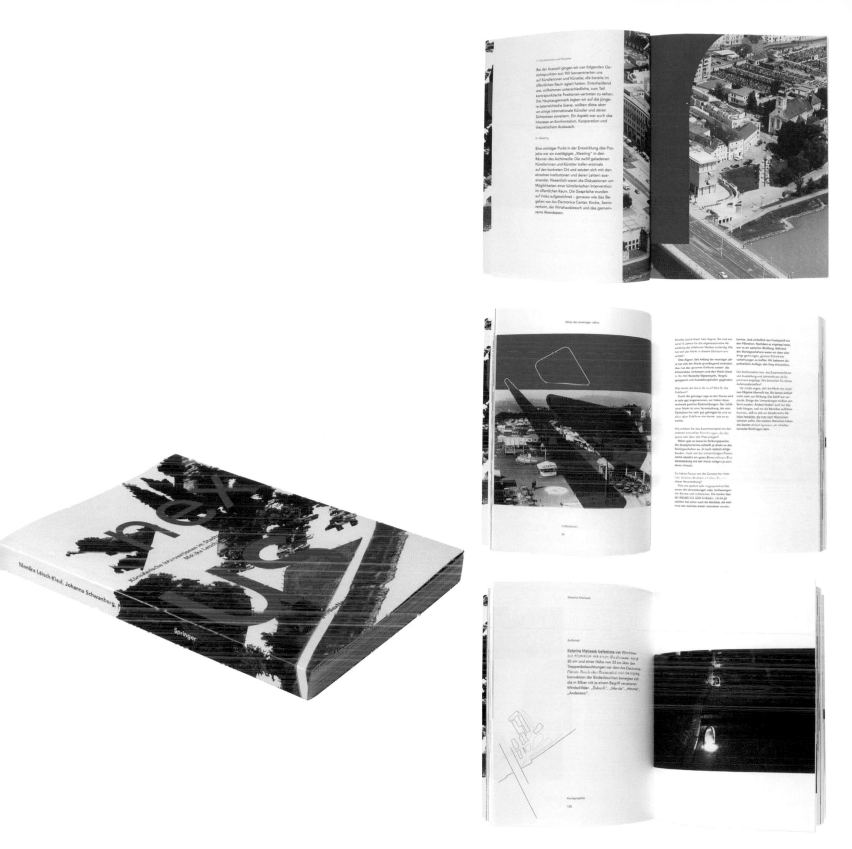

Design: Richard Ferkl

Project: Nexus

Authors: Monika Leisch-Kiesl &
 Johanna Schwanberg

Publisher: Springer

Size: 230 x 173mm (9 x 6¾in)

Pages: 232

Year: 1999

Country: Austria

The book documents a series of site-specific
public installations. Each chapter presents a
particular installation, working up from macro to
micro views of the area occupied by the piece.
Fragments of maps printed in solid blocks of red
are used as abstract shapes on the page. The
letterforms from the title are used in a similar
manner and printed over black and white views
of the spaces.

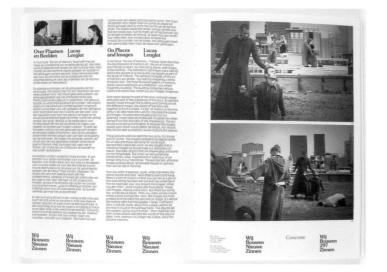

Design: Experimental Jetset

Project: Wij Bouwen Nieuwe Zinnen

Publisher: W139

Size: 241 x 171mm (9½ x 6¾in)

Pages: 382

Year: 2002

Country: Holland

A grid of 40 units (4 x 10) is used to structure this piece by the Dutch design company Experimental Jetset. *Wij Bouwen Nieuwe Zinnen* ('We Build New Sentences') is repeated across the bottom of all pages, with folio numbers and titles of works dropped into the last two units on each spread. The grid device is used to punctuate the book throughout. An index is printed on the inside back flap of the cover with details of all the projects.

Design: Lust
Project: Stad in Vorm
Publisher: Uitgeverij 010 Publishers
Size: 300 x 222mm (11⅞ x 8¾in)
Pages: 304
Year: 2000
Country: Holland

Stad in Form documents architectural projects in The Hague over a period of 15 years. The design is based on a classification system and helps to guide the reader through different layers of information. The ten chapters, each covering a different kind of architectural planning (residential, etc), are colour-coded. The colours are used in conjunction with an alphabetical numbering system, which runs from A to J (in effect, one to ten). As such, each building is given an individual serial number comprised of a letter and a colour. On the inside of the dust jacket are maps of The Hague showing only the areas mentioned in the text. Thus a cluster of green numbers on a map reveals that that part of the city is mainly, say, residential.

Design: Friedrich Forssman & Ralf de Jong
Project: Detail Typografie
Authors: Friedrich Forssman & Ralf de Jong
Publisher: Verlag Hermann Schmidt, Mainz
Size: 303 x 215mm (12 x 8½in)
Pages: 376
Year: 2002
Country: Germany

This beautifully designed book examines in great
detail every aspect of typographic design. The
book is predominantly printed in black and white,
with an extra pale-cream colour artfully used to
highlight illustrations.

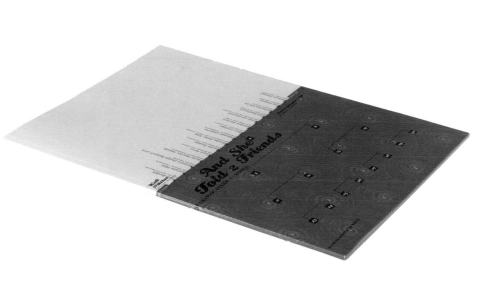

Design: Kali Nikitas
Project: And She Told 2 Friends
Author: Kali Nikitas
Publisher: Michael Mendelson Books
Size: 333 x 235mm (13⅛ x 9¼in)
Pages: 40
Year: 1996
Country: United States of America

This book was produced to accompany a touring exhibition of graphic-design work by women. The concept for the show – curated by the designer of this piece, Kali Nikitas – is encapsulated in the title: Nikitas invited two women to submit work and then asked each of them to extend similar invitations to two other women, and so on. In effect, the exhibition curated itself. The book works in a similar way, starting in the centre with Nikitas and illustrating graphically the chain of events that followed, with Nikitas's two friends appearing on either side of her. Projects spread progressively forwards and backwards until the front and back of the book are reached. Uncoated orange stock is used as punctuation at the centre and outer ends of the book.

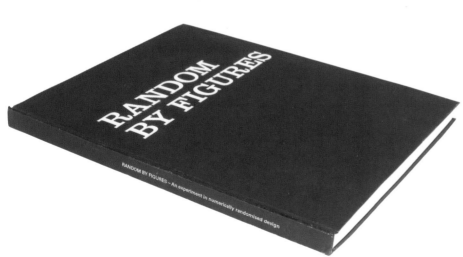

Design: Park Studio
Project: Random by Figures
Authors: Linda Lundin & Marianne Lydersen
Publishers: Park Studio
Size: 248 x 204mm (9¾ x 8in)
Pages: 86
Year: 2001
Country: United Kingdom

The designers used a random-number generator to determine page structure. Various elements – body text, headline, captions, images – were all decided by the random intervention of the generator. Even the dimensions of the book and the total number of pages were determined by this process. The end result is far from mundane – the process creates some original layouts and interactions. The final piece was produced as a limited-edition artist's book, which was output in the form of black and white laser copies French-folded and case-bound.

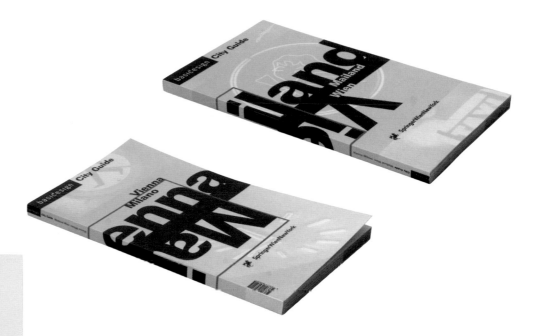

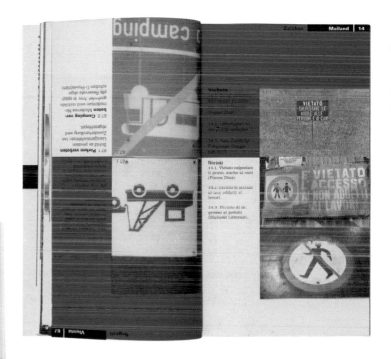

Design: Perndl + Co
Project: Basic Design: City Guide
Publisher: Springer
Size: 234 x 132mm (9¼ x 5¼in)
Pages: 176
Year: 1996
Country: Austria

This pocket guide to Vienna and Milan compares everyday design elements from the two cities. The book is double-fronted, with one city starting at the front and the other at the back (upside down). However, the two accounts do not simply meet in the middle, but instead both run throughout the volume on the right-hand page of each spread, depending on which way up you hold the book. As such, the guide allows the reader to make instant cross-references between the cities as well as to study them independently: the same 'design elements' for the two cities are profiled on the same spreads. The approach produces some striking layouts, with juxtaposed images printed in red and black in both orientations.

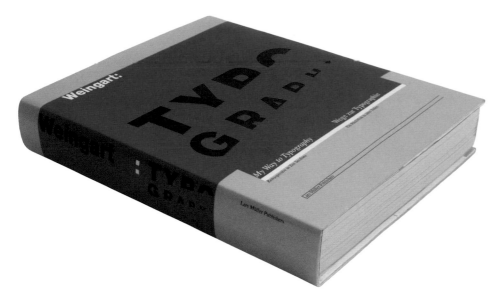

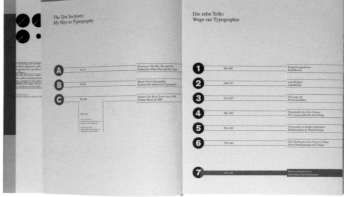

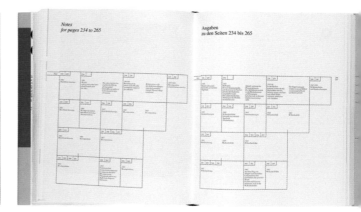

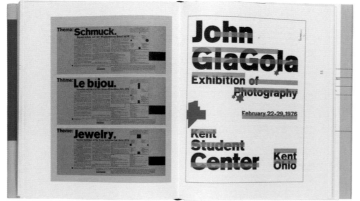

Design: Wolfgang Weingart
Project: My Way to Typography
Author: Wolfgang Weingart
Publisher: Lars Müller Publishers
Size: 280 x 230mm (11 x 9in)
Pages: 520
Year: 2000
Country: Switzerland

Designed and written by Wolfgang Weingart, this heavy tome chronicles the legendary designer's influences, thinking, development and practice. It is divided into ten sections: the first three, Discovery, Quest and Insight, are assigned alphabetical reference letters: A, B and C. There then follow seven case studies, or 'independent projects', illustrating the development of ideas and strategies presented in the opening sections of the book. Caption text is removed from the spreads and relocated to the back of each chapter like a series of endnotes contained in a flatplan grid of boxes.

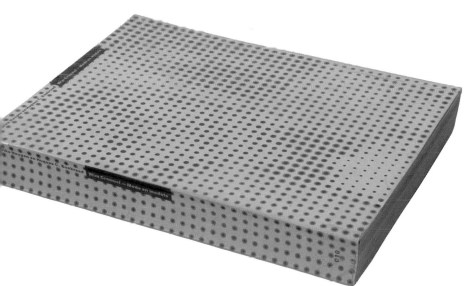

Design: Karel Martens
Project: Wim Crouwel – Mode en Module
Authors: Frederike Huygen & Hugues C. Boekraad
Publisher: Uitgeverij 010 Publishers
Size: 230 x 177mm (9 x 7in)
Pages: 432
Year: 1997
Country: Holland

This is a densely packed volume that illustrates every item of Wim Crouwel's work to date. The first section of the book, printed in black and white, deals with Crouwel's development and is illustrated with archival images and press cuttings. This is then followed by the main body of the book, printed in full colour, which chronicles his output from 1947 to 1997. Most images on these pages have full accompanying captions: each picture is given a reference number, running from 1 to 1606. The cover features an abstracted portrait of the designer produced by breaking a photograph of Crouwel down into a series of coloured circles. The image only becomes readable from a distance.

Design: Irma Boom
Project: Otto Treumann
Publisher: Uitgeverij 010 Publishers
Size: 240 x 192mm (9½ x 7⅗in)
Pages: 244
Year: 2001
Country: Holland

There is a strong flavour of Irma Boom in this book about another great Dutch designer, Otto Treumann. That was precisely the publisher's intention – it wanted an interaction between two renowned Dutch designers from different eras.

The book plays with the idea of repetition: as Treumann produced a great many posters and stamps during his illustrious career, this sense of multiplicity seems appropriate. A series of colour

tabs are printed on the edge of every page, with small image numbers hanging off them. Full caption details for these images are given at the back of the book; numbers with a 'D' prefix are documentary images, i.e. photographs. All numbers feature the year in which the work was created, so 63.3 indicates, for instance, that this is the third image shown from 1963.

Design: J. Abbott Miller/Pentagram

Project: Wonderland

Publisher: The Saint Louis Art Museum

Size: 256 x 230mm (10⅛ x 9in)

Pages: 176 + 10 posters

Year: 2000

Country: United States of America

This book was produced for a large group show of installation art at the Saint Louis Art Museum in America. The designers were faced with a serious logistical problem: the work in the exhibition would not be finished in time to be photographed and included in the book prior to the opening of the exhibition. Their solution involved producing a book containing background information about the artists which would then be supplemented at the last minute by a series of folded posters/broadsheets showing the completed installations. The two elements were put together in a polypropylene slipcase. A series of colour-coded squares were included in the book and used prominently on the front of each folded poster to reinforce the link between the two otherwise disparate-looking elements.

Design: Aufuldish & Warinner

Project: The Logan Collection: A Portrait of
our Times

Publishers: Vicki and Kent Logan

Size: 292 x 214mm (11½ x 8½in)

Pages: 224

Year: 2002

Country: United States of America

Housed within a matt laminated slipcase, this
lavishly produced cloth-covered, case-bound book
features a holographic block on its front cover.
Inside, a vibrant fluorescent green has been
used throughout for divider pages and drop caps.
A series of thumb-cut tabs aid navigation
throughout the book.

A 30-Year Flash (Part II)

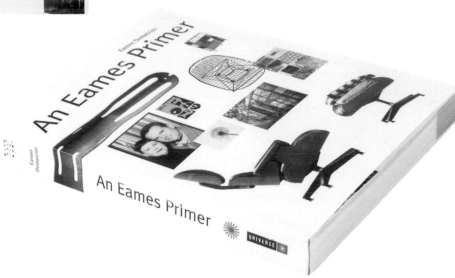

Design: Ph.D
Project: An Eames Primer
Author: Eames Demetrios
Publisher: Universe Publishing
Size: 210 x 164mm (8¼ x 6½in)
Pages: 272
Year: 2001
Country: United States of America

This small, text-heavy book gives a great insight into the world of the famous husband-and-wife design team. A single, wide column of text is offset by a narrow column running down the outer edges of the page containing notes and captions.

A series of photographs are printed at the bottom outer corner of every right-hand page. These images show a 'walk through' the Eames office at 901 Washington Boulevard. Although the images do not quite run together to provide a fluid flick book, the reader can nonetheless get a good feel for the environment in which these great designers worked.

Interview:
Derek Birdsall,
designer

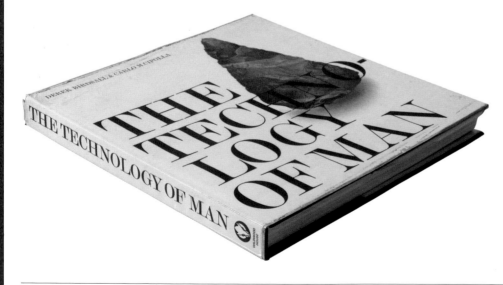

'I'm rather boringly sensible.' Derek Birdsall has been described as many things over the years, but boring is not an adjective that springs to mind when considering the impressive body of work he has built up over the past four decades. His career has been well documented. He grew up in Scarborough, where he met his wife (and typesetter) Shirley. After Wakefield College of Arts & Crafts, Birdsall went on to study under Anthony Froshaug at the Central School of Art in London. Froshaug had a profound influence, instilling in him discipline, a love of order and an aversion to anything style- as opposed to content-driven. 'People have said to me, "Oh, you're a minimalist,"' he smiles. 'I may be taking a minimalist approach, but why be complicated? Life's complicated enough.'

Birdsall was one of the four founders of BDMW Associates in 1960, and for the next 20 or so years he worked on many corporate-identity projects, as well as the infamous Pirelli calendars. He designed several Monty Python books, art-directed *Town*, *Twen*, *Nova* and *Connoisseur* magazines and numerous book jackets for Penguin. The covers of the Penguin Education series, which Birdsall worked on from 1963 onwards, with their white backgrounds, witty graphics and economical use of type, were particularly successful.

He set up Omnific Studios with Shirley in 1983 and in recent years has mainly (though not exclusively) undertaken commissions for books, developing a reputation for producing immaculate, heavyweight editions of the works of artists such as Mark Rothko, Georgia O'Keeffe and Alfred Stieglitz. Though he works in a tranquil studio in the basement of his Islington townhouse, Birdsall is good company – he has a dry sense of humour and a string of well-worn but still amusing anecdotes. Recent projects have included a book for the National Gallery of Art in Washington, DC on Italian fifteenth-century art and a catalogue for a touring exhibition from the Vatican, which he likes to refer to as 'the Italian jobs'. Another significant tome – 15 years in the making – is his own much-anticipated guide to book design, featuring examples from volumes he has designed over the years.

When he describes himself as 'boringly sensible' Birdsall is modestly referring to the fact that he approaches every project with humility, intelligence and lots of what he calls 'common sense'. He is not interested in design that is conspicuous or that detracts from the subject matter by 'showing off'. 'One of the paradoxes of book design is that it shouldn't be visible at all,'

Project: The Technology of Man

See page 128

he explains. 'It should look as if it just happened. One of the most comforting things about finishing a job is when you look through it and think, "So what?" It's trying to get a personality for a book and make it just a little bit interesting. Just short of boring is fine.'

Birdsall's private obsession with scale is well known and his system of 'proportional representation' seems fairly obvious when he explains it: 'It's one of the capital crimes. Never, ever show an image of something bigger than something that it is smaller than in reality. The same size is okay, but not bigger.' Birdsall can see why this precept is often ignored: 'In a sense, the best – and the worst – reason for it happening is that somebody likes one picture more than they do the other. In a strange kind of way, that's quite affecting.' It can also be very hard to stick to the rules of 'proportional representation' when a designer is faced with one bad-quality and one good-quality transparency – Birdsall admits to succumbing to the temptation in such circumstances in the past.

Birdsall has not yet succumbed to the lure of the Apple Mac, however. He still works in paste-up: 'It's a conscious decision because I know that I would spend all my time on the computer. I'd be an anorak... I'd have no time to think.' He also thinks that computers are deceptive in terms of scale and mean that designers can end up using barely legible 4-point type: 'I'm convinced that this can only happen because somebody's been able to look at it at 200 per cent to check the spelling.'

Birdsall is not a slave to Tschichold's theories on book design: 'I don't hold any truck with these Golden Margins – it's whether it looks nice and how it works the best that matters.' Instead he works on instinct; creating a bigger inside margin if the book is to be tightly bound, and whenever possible sticking to his preferred column width: 'I love round numbers – they're easy to remember. My favourite column width is 100mm, simply because when it's 100, if something's going to be reduced or enlarged it's just a percentage.'

One of Birdsall's most accomplished projects is the highly acclaimed *Common Worship*, the new edition of the Church of England's prayer book, and successor to the Alternative Service Book. Set entirely in Gill Sans, Birdsall's design (created with his then-assistant, John Morgan) is elegant and economical, and at the same time extremely legible. This was an important factor, not least because the book is often read by people with less than perfect eyesight in dim light. Birdsall has breathed life into it by his considered typography – italics, red ink and sometimes a combination of the two help to guide the reader though the book's complex text. *Common Worship* was completed in a year, but things were made much easier because all the material was available from the start – something that never happens with big art books, where elements arrive at different times, and in no particular order. Birdsall finds it frustrating, likening it to directing a film, where you have to shoot out of sequence. It can be hard to dictate the pace of a book when you don't see all the content together until completion.

Birdsall found the Church an ideal client, and the book was very well received by the religious community – so much so, he has now been asked to work on a Catholic prayer book. 'Typography and the Church have been in cahoots for 500 years. It's what printing was invented for,' he explains. The cover of *Common Worship* is typical Birdsall. It's playful and economical; most of all it looks completely effortless. He is adamant that such design is not the result of what he describes as a 'eureka moment': 'It was a discovery... It's about being receptive. I insist that the best way to design is discovery. If you discover something by looking at the material, it's endemic to the material. It's not welded on, attached, stuck-on style. To me, it's the most satisfying thing in the world.'

Project: Common Worship
See page 103

Typography

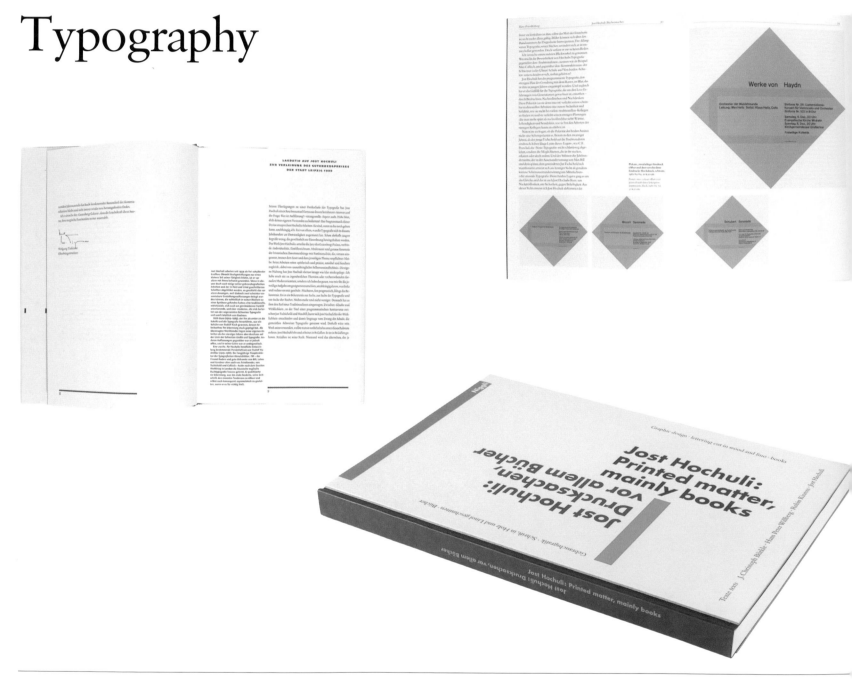

Design: Jost Hochuli

Project: Jost Hochuli: Printed Matter, Mainly Books

Editors: J. Christoph Bürkle, Hans Peter Willberg,
 Robin Kinross & Jost Hochuli

Publisher: Niggli

Size: 300 x 200mm (11⅞ x 7⅞in)

Pages: 212

Year: 2002

Country: Switzerland

Charting a highly impressive design career, this beautifully produced book showcases a great many pages from the designer Jost Hochuli's portfolio. The text is printed in German and English. The two languages run alongside one another, set in the same serif font – this gives the body text an even quality so that the languages do not compete for attention. However, the German caption text is set in demi-bold and the English caption text in book, a distinction necessary to avoid confusion on the page, as the captions contain German titles in both languages.

The use of illustrations has a vivacity and fluidity typical of much of the designer's output. The grid system is ever-present in the constant positioning of the caption text, which is always

...igned with the bottom margin of the book. ...he cover boards of the book are trimmed flush ...the text pages, creating a solid book block that ...eatly encapsulates the overall precision of the ...esign and quality of the production.

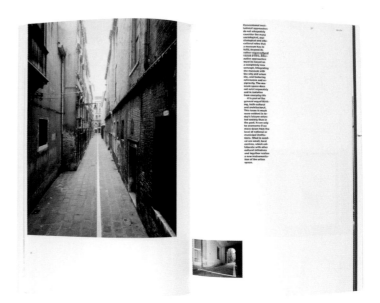

Design: A.G. Fronzoni, Christian Aichner &
　　　　Bernd Kuchenbeiser
Project: A.G. Fronzoni
Publisher: Edition Salach/Lars Müller Publishers
Size: 275 x 177mm (10⅞ x 7in)
Pages: 54
Year: 1998
Country: Italy/Switzerland

Reflecting the lightness of touch of the great
Italian designer A.G. Fronzoni, this simple little
book dispenses with a title or any other clue as to
its contents on the outside. Instead, a single line of
text wraps itself around the cover, beginning on the
inside back flap and ending: 'words left unspoken,
unrequited love, giving, to become poorer –'.

Inside, the book further echoes the style
of the designer with its use of narrow columns of
text, giving a fluid, vertical dynamic to the page.
All typography is set in 6pt Univers bold; the folios
are in Univers light.

Design: Stuart Bailey
Project: In Alphabetical Order
Author: Stuart Bailey
Publisher: NAi Publishers
Size: 240 x 170mm (9½ x 6¾in)
Pages: 96
Year: 2002
Country: Holland

Title, barcode and publisher's details are all printed on a small white adhesive label stuck roughly in the top right-hand corner of the cover. The cover image is a photograph of a blackboard at the Werkplaats Typografie design school, with words arranged in alphabetical order as a visual reference to the work's title.

The book relates to an exhibition at the Stedelijk Museum in Amsterdam and focuses on the output of the Werkplaats Typografie. The main part of the book is printed in black and white, with 6pt editorial text overprinted in red. The constant use of red throughout creates unity in what is otherwise a very varied book typographically. The last section shows full-colour images of the exhibition.

"Ideally I'd like to live somewhere where I could leave my bloody front door open and know damn well that nobody's going to walk through it and nick my stuff... I'd like to live somewhere where there's a community spirit that involves all the community and not just certain groups, and I'd also like to live somewhere where I don't see heroin and crack cocaine being dealt openly on my street..." Citizens Workshop

Structure
096/097

Design: Cartlidge Levene
Project: Towns & Cities,
 Partners in Urban Renaissance
Publisher: Office of the Deputy Prime Minister
Size: 220 x 165mm (8⅝ x 6½in)
Pages: 132, 108, 224 & 96 (four books)
Year: 2002
Country: United Kingdom

The four separate volumes are held together by a paper bellyband. The clean, restrained look of the covers finds a counterpoint in the right edge being cut 15mm (⅝in) short to reveal full-colour images beneath.

The typography throughout is set in a clean serif font in warm greys. Each volume has its own secondary colour – magenta, lilac, turquoise and green. These are used to highlight key words and phrases within the grey text. Quotations are set in a larger point size and run across entire double page spreads.

Structure
098/099

Design: Base Design
Project: Works from 01.97 to 05.00
Publisher: Base Design
Size: 220 x 160mm (8⅝ x 6¼in)
Pages: 132
Year: 2000
Country: United States of America

This was produced as a showcase by and for the New York/Brussels/Barcelona company Base Design. A dot-matrix font is used throughout; characters are generated out of a 5 x 8 grid of small dots which provide the framework for the letterforms. This background grid is visible wherever text appears. This same system is used on the cover, where a single letter fills the space and only really becomes legible when seen from a distance. The company name is spelt out over the front, inside-front, inside-back and back covers. The book is clothed in a soft PVC dust jacket.

Design: Hamish Muir

Project: Cyber_Reader

Editor: Neil Spiller

Publisher: Phaidon Press

Size: 250 x 177mm (9⅞ x 7in)

Pages: 320

Year: 2002

Country: United Kingdom

This book contains 43 essays by 43 writers, whose names are used to create a typographic cover. Each essay begins with a solid black spread, with text printed in white and grey. The remainder of the text is printed in black on a plain white background. This device helps to enliven the pace of what is essentially an academic book containing only a small quantity of illustrations. The introductory text and endpages are printed with a vibrant green background to help differentiate them from the main body of the book. The few visuals that do appear are printed with a neutral grey background, with caption text placed across their top edges.

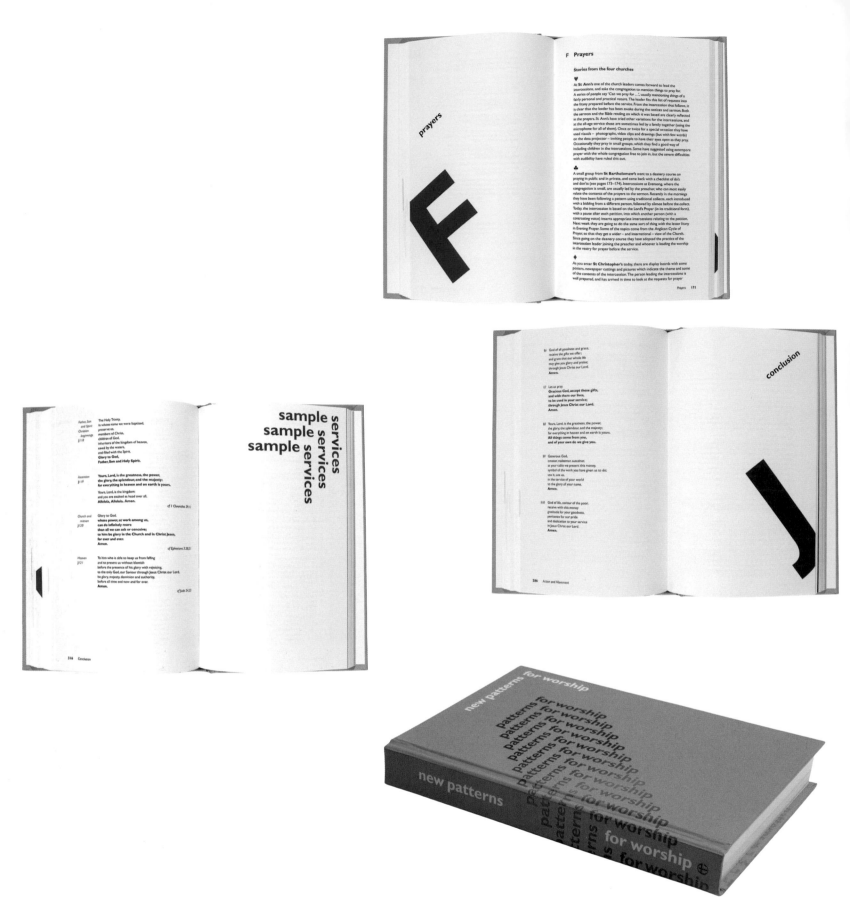

Design: Derek Birdsall
Project: New Patterns for Worship
Publisher: Church House Publishing
Size: 256 x 160mm (10 x 6¼in)
Pages: 502
Year: 2002
Country: United Kingdom

Created by Birdsall after he had completed the highly praised *Common Worship* (see page 103), this book follows the same typographic styling, with text printed in black and red in Gill Sans. The cover includes a typographic play on the title, set in a multi-coloured palette of colours against a warm grey background.

Chapters bear letters from A through to J, which are printed on the chapter divider pages set at a very large size at a 45° angle, echoing the style of the cover. A series of typographic symbols based on the suits in a pack of playing cards are used throughout the book to represent four imaginary churches: St Ann's (hearts), St Bartholomew's (clubs), St Christopher's (diamonds) and St Dodo's (spades).

Design: Attik
Project: NoiseFour
Publisher: HBi
Size: 337 x 227mm (13¼ x 8⅞in)
Pages: 504
Year: 2001
Country: United Kingdom

This is the fourth and most ambitious and lavish book produced as the ongoing documention of the work of the international design consultancy Attik. The book features creative doodles and commercial work, often mixing the two elements together. The typography reflects an informational aesthetic – set predominantly in upper-case Akzidenz Grotesque – but with some sections printed in eye-strainingly small point sizes.

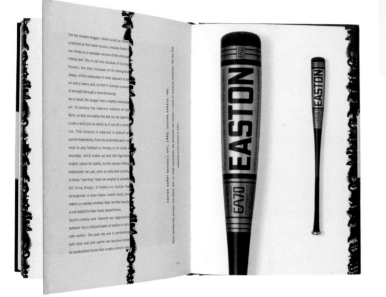

Design: Aufuldish & Warinner
Project: Icons: Magnets of Meaning
Editor: Aaron Betsky
Publisher: Chronicle Books
Size: 235 x 158mm (9¼ x 6¼in)
Pages: 272
Year: 1997
Country: United States of America

This catalogue was designed for an exhibition at the San Francisco Museum of Modern Art about a series of design and cultural artefacts that the curators felt had achieved iconic status. Four essays are each given a different typographic treatment. Interestingly, each essayist had approval for the design of their essay – the form/content explorations are 'author-approved'.

A mass of overprinted fragments of icons and corporate logos extends down page edges and is also used as a device to separate sections of text.

Design: Derek Birdsall

Project: Common Worship

Publisher: Church House Publishing

Size: 210 x 135mm (8¼ x 5¼in)

Pages: 852

Year: 2000

Country: United Kingdom

Elegantly set in Gill Sans, and printed in red and black on a cream bible paper, this resetting of the Church of England's Book of Common Prayer was produced with great care and attention to detail. For instance, no text is allowed to run over the page onto the following spread to avoid a lot of page-turning noise being generated during a prayer. The grid has also been positioned with consideration to the inevitable show-through on such a light paper stock. Four coloured ribbons are included so that worshippers have access to multiple place-holders. The book itself is available in various cover finishes, from deluxe leather to a special white edition for weddings.

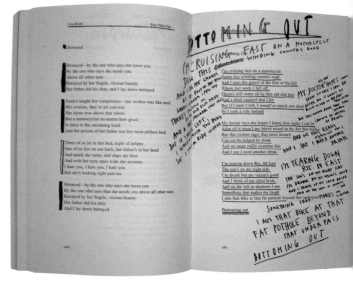

Design: Sagmeister Inc.

Project: Lou Reed – Pass thru Fire:
 The Collected Lyrics

Publisher: Bloomsbury

Size: 210 x 140mm (8¼ x 5½in)

Pages: 472

Year: 2000

United States of America

The collected lyrics of the musician Lou Reed are set using a classically derived grid system: a single column of ranged-left text with author and song title given across the top above a rule; folios at the foot of each page in a clean serif font. However, the rules are broken or subverted on almost every page, as the designer develops typographically playful elaborations for almost every set of lyrics. Some pages remain calm, with only subtle adjustments; settings on other pages suggest free form abstract poetry. Some lyrics are variously blurred, out of focus, upside down, back to front, reversed out of solid black, or have handwritten doodles scrawled over them. The sleeve notes of *Metal Machine Music*, an experimental instrumental album, are reproduced with black rules obliterating the text.

Design: Tonne

Project: Technological Landscapes

Author: Richard Rogers

Publisher: RCA CRD Research

Size: 190 x 140mm (7½ x 5½in)

Pages: 104

Year: 1999

Country: United Kingdom

The design of this predominantly text-heavy book plays with the edge of the page. All the chapter headings – which are invariably three or four lines long – are set in a quirky bold font ranged left so that the first word on each line bleeds off the page. This creates a series of black bars that are visible down the fore-edge of the book.

The book derives maximum effect from a single colour. Graduated-tint vignettes extend over whole pages, offset by boxed information also printed in tints but with the graduation running in the opposite direction.

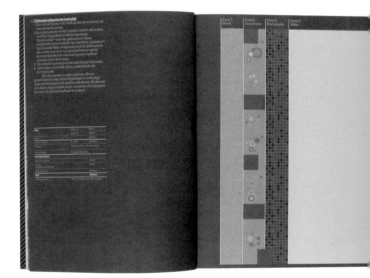

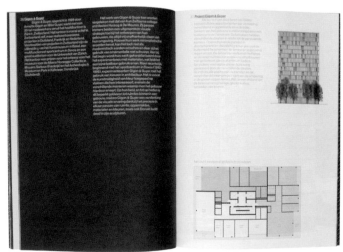

Design: Spin
Project: Antwerpen Kattendijk dok
Publisher: Project 2
Size: 297 x 210 (11¾ x 8¼in)
Pages: 32
Year: 2002
Country: United Kingdom

A slim volume showcasing proposals for an
architectural development in Antwerp, Belgium.
The book's striking palette of colours is applied
to black and white images, architectural drawings
and the typography.

Design: Marcus Ainley Associates
Projects: Changing Platforms & Bloody Amateurs
Publisher: Unknown Public
Size: 290 x 143mm & 215 x 143mm
 (11½ x 5⅝in & 8I/2 x 5⅝in)
Pages: 100 & 64
Years: 2001 & 2002
Country: United Kingdom

Although of different sizes, these two issues of Unknown Public's experimental musical journal have a consistent feel. Both use the same grey uncoated stock for the spine section and a matt laminated cover image. This traditional binding method is offset by the modernity of the images and type used.

Within, the same grid and type hierarchies are used, but different fonts have been adopted – FF Meta in *Changing Platforms*, Foundry Sterling in *Bloody Amateurs*.

Design: Michael Worthington
Project: Flight Patterns
Publisher: The Museum of Contemporary Art,
 Los Angeles/DAP
Size: 260 x 212mm (10¼ x 8⅜in)
Pages: 160
Year: 2000
Country: United States of America

Produced to accompany a group show at the
Museum of Contemporary Arts in Los Angeles,
this book utilizes both coated and uncoated paper
stocks throughout. A series of full-bleed images
on a coated stock at the front of the book is
followed by an introductory section printed on
uncoated stock with a strong yellow background.
The main body of the book prints the artists'
work on coated stock. The back of the book

returns to an uncoated stock with a strong yellow
background. Blocks of text are highlighted in
white panels and central margins are left white.
As a result, a strong contrast is created between
the section on the artists' works and the editorial
elements at the front and back of the book.

Design: Alan Fletcher
Project: The Art of Looking Sideways
Author: Alan Fletcher
Publisher: Phaidon Press
Size: 252 x 212 x 60mm (10 x 8⅜ x 2⅜in)
Pages: 1,066
Year: 2001
Country: United Kingdom

A series of thoughts, questions and riddles start on the front cover, wrap around onto the back and continue inside this hefty volume from the great designer Alan Fletcher. A huge array of different fonts and stylings are used in this book, which is intended not just for fellow designers but everyone in the habit of asking questions. Every page (in fact, a spread counts as a single page, the last folio in the book being 533) contains numerous ideas and insights, but can be dipped into at any point, functioning as a kind of random-access database.

Grids

Design: Helmut Schmid
Project: The Road to Basel
Publisher: Helmut Schmid Design
Size: 260 x 258mm (10¼ x 10⅛in)
Pages: 96
Year: 1997
Country: Japan

A beautifully restrained piece of typographic design, the book contains recollections by former students of the Swiss design teacher Emil Ruder. Printed with German, English and Japanese texts, it perfectly harmonizes these very different-looking languages.

The quietness of the design is offset by a fluidly playful grid system which allows columns of text to rise and fall and so prevents the design from becoming too static. The same rhythms are repeated in each of the languages. The folios, which are placed at the foot of the page, have an extraordinary lightness, moving laterally across the page and hanging from the edge of an image or a column of text. The book suggests a very positive future for the classic three-column grid system favoured by Ruder's followers.

esign: Helmut Schmid
roject: Typography Today (new edition)
ditor: Helmut Schmid
ublisher: Seibundo Shinkosha
ze: 297 x 225mm (11¾ x 8⅞in)
ages: 184
ear: 1980 (original)/2003 (new edition)
ountry: Japan

This new, revised and extended edition of the seminal, almost mythical book on modern typography has been digitally remastered. It is a who's who of modern typography, featuring all the greats and a few less well-known designers, and printed in both English (set in Univers) and Japanese (set in a suitably clean and discreet-looking type).

The first section of the book features a horizontal grid system, with all editorial information running vertically up the page and a series of six black tabs, which denote the gutters in the grid, appearing on all left-hand pages. This is then followed by a section with more conventionally set text. The last section reverts to the horizontal grid, again with black tabs, though this time highlighting the column widths.

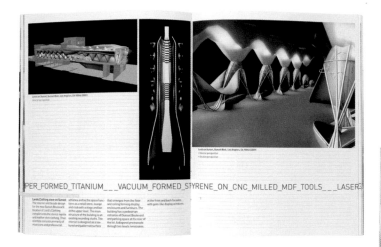

Structure
112/113

Design: COMA
Project: Architectural Laboratories
Authors: Greg Lynn & Hani Rashid
Publisher: NAi Publishers
Size: 248 x 195mm (9¾ x 7¾in)
Pages: 176
Year: 2002
Country: United States of America/Holland

Along with students from Columbia University and the University of California, architectural theoreticians and practitioners Hani Rashid and Greg Lynn transformed the United States Pavilion into a four-week workshop during the Venice Biennale 2000.

This book provides a record of the event and has the same 'work-in-progress' quality as the workshop itself. All images hang from the top of the page; tools and materials are listed in one long sentence running throughout the book. Each new chapter begins with an underlying snapshot image of the students participating in the workshop. The baseline grid is visible on all pages in the form of a series of white lines.

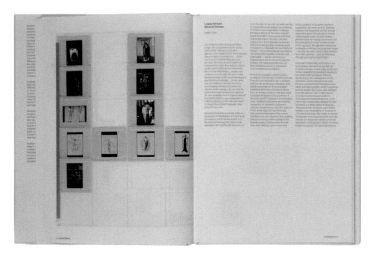

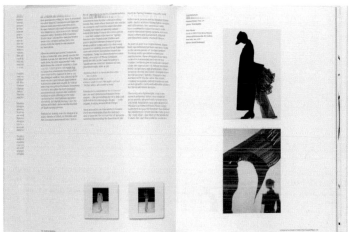

esign: A2-Graphics/SW/HK

oject: Radical Fashion

itor: Claire Wilcox

blisher: V&A Publications

ze: 328 x 238mm (12⅞ x 9⅜in)

ges: 148

ar: 2001

untry: United Kingdom

For this book, produced to accompany a major exhibition at the Victoria & Albert Museum in London, the designers created a bespoke font – FY-V&A. The work is split into two sections. The first is printed on uncoated paper and features a series of essays. The second, printed on a smooth coated paper, shows work by a variety of contemporary fashion designers.

In the first section of the book, all the images are shown as 35mm transparencies set in standard clear-plastic slide holders. The rest of the book employs a more flexible grid system to allow for images to be shown full-bleed or cropped.

Structure
114/115

Design: Bohatsch Graphic Design
Project: Ingo Nussbaumer:
 Painting as a Proposition
Publisher: Triton Verlag
Size: 305 x 243mm (12 x 9⅝in)
Pages: 72
Year: 1997
Country: Austria

The cover boards, which feature a work by the artist, fall short on the bound edge, so revealing the black cloth spine. Inside, the book uses a complex grid system for the essays; the main body text is interspersed with quotations that cut into it from the left. Two further small columns are used for footnotes – the farthest left contains notes relating to the quotations, while the column to its right contains notes relating to the main text.

This asymmetric grid bears a close relationship to the artist's work, but replacing his characteristic blocks of colour with blocks of words.

Design: Bohatsch Graphic Design

Project: Massiv

Publisher: Triton Verlag

Size: 246 x 165mm (9¾ x 6½in)

Pages: 96

Year: 2001

Country: Austria

Massiv makes full use of its two-colour printing (black and neutral grey-green). Main text is set in a single wide measure and is printed in black; notes appear in the bottom left of pages in grey. The rhythm is occasionally varied by the inclusion of pieces of concrete poetry and images of artworks printed onto a grey-green background.

Structure

116/117

Design: CHK Design

Project: Restart: New Systems in Graphic Design

Authors: Christian Küsters & Emily King

Publisher: Thames & Hudson

Size: 297 x 210mm (11⅝ x 8¼in)

Pages: 176

Year: 2001

Country: United Kingdom

Showcasing experimental work by cutting-edge international graphic designers, this book uses a grid system derived from Adrian Frutiger's 1954 diagrammatic display of his Univers font. Each box shows a different variation of the 21-weight font. The setting of the text faithfully follows the scheme, changing to the appropriate weight as the text runs on from box to box.

The chapter titles show all 21 font versions overprinted. This results in the words being obliterated by themselves.

Design: Wim Crouwel

Project: The Preference for the Primitive

Author: E.H. Gombrich

Publisher: Phaidon Press

Size: 252 x 182mm (10 x 7⅛in)

Pages: 324

Year: 2002

Country: Holland

For this work by the great art historian Sir Ernst Gombrich, Crouwel's classically simple serif typography follows the traditions of quality book setting. However, the folios have been moved a third of the way down the page, always appearing on the left of the page, giving the layouts an asymmetric quality. Caption text follows the same principle.

Design: Philippe Apeloig
Project: The Spiral, the Hand and the Menorah
Publisher: Gabriele Capelli Editore
Size: 210 x 152mm (8¼ x 6in)
Pages: 36
Year: 1999
Country: France

Produced for the Museum of Jewish Art and History in Paris, the six-page cover opens to reveal a concertina-folded book placed in the central panel. The book is printed on a heavy uncoated board, so the pages have a rigidity as they are turned. Typography and image move freely around the page, creating a fluidity of form. The text is printed in two languages, French in black and English in warm grey.

Design: Büro für Visuelle Gestaltung

Project: The New St. Pölten

Publisher: Springer

Size: 287 x 174mm (11¼ x 6⅞in)

Pages: 120

Year: 1997

Country: Austria

The text of this architectural profile of the Austrian federal state capital is set in black (German) and muted grey-green (English). The two languages run side by side in two and three columns. The thread-sewn sections of the book use a grey-green thread to match the colour of the print.

Design: Büro für Visuelle Gestaltung
Project: Emerging Architecture vols 1 & 2
Author: Otto Kapfinger
Publisher: Springer
Size: 220 x 156mm (8⅝ x 6⅛in)
Pages: 256 (each)
Year: 2000 & 2001
Country: Austria

This annual publication presents new architecture from Austria and neighbouring countries. It combines versions of the text in both German (serif) and English (sans serif), printed in two colours: black and light blue in volume 1, black and olive-green in volume 2.

The two blocks of text, German and English, are cleverly offset, the English placed at the top of the page with the German below it. Caption text runs vertically up the page, with key words related to the projects printed in a tint of the second colour.

The books have been bound with coloured thread that picks up on the secondary text colour

Design: Base Design

Project: FAD Convent dels Àngels

Publisher: FAD

Size: 205 x 300mm (8⅛ x 11⅞in)

Pages: 176

Year: 2001

Country: Spain

Making the most of its wide panoramic format, the book places text and images in various-sized boxes on a complex interlocking grid system. The latter evokes the architectural qualities of the building the book is about, as is visible in the front-cover image of its façade.

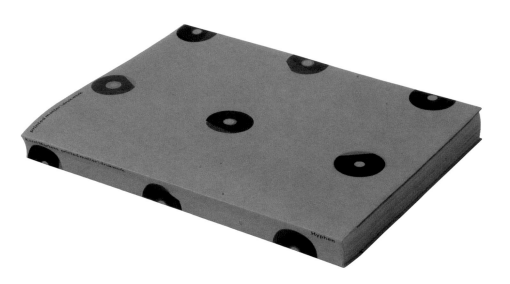

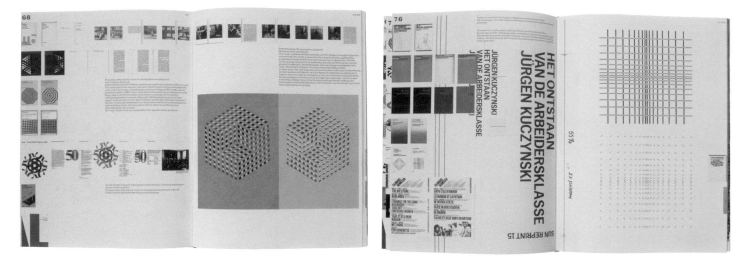

Design: Karel Martens
Project: Printed Matter/Drukwerk
Publisher: Hyphen Press
Author: Robin Kinross
Size: 233 x 172mm (9⅛ x 6¼in)
Pages: 168
Year: 1996 (original edition)/2001 (new edition)
Country: Holland

Originally produced in 1996, the revised and extended version of this book comes in a paper wrap which features text in Dutch and English drawing attention to the award it won at the Leipzig Book Fair. Inside, the design beautifully demonstrates the benefits of French-folded pages: text is pushed out to the absolute limit – just 1mm (⅛in) from the edge of the page. Images wrap around the folds or are placed right at the pages'

edges. The book is printed using a raster screen, which allows 6pt type to be printed in tints and still to retain legibility and clarity. Even using a fine standard dot screen, it would be very hard to maintain such detail. The book has something of the quality of a scrapbook, with densely packed images fluidly arranged around the page.

Design: Sans + Baum
Project: The Designer and the Grid
Authors: Lucienne Roberts & Julia Thrift
Publisher: RotoVision
Size: 257 x 257mm (10⅛ x 10⅛in)
Pages: 160
Year: 2002
Country: United Kingdom

Demonstrating by its own design the joy of grids, this square-format book has a seven-by-seven-column grid system which it uses in every way imaginable, with text running both vertically and horizontally. Negative space is filled with blocks of colour. Captions and other bits of text are placed within different-shaped slabs of yellow. A seven-column series of drop-down menu/chapter options, inspired by the digital world of computer menus, run across the top of the page. The danger always exists that the design of a book can overpower its content. However, the overall effect works well here to show that grid systems are not straitjackets, but can be used creatively to enliven material.

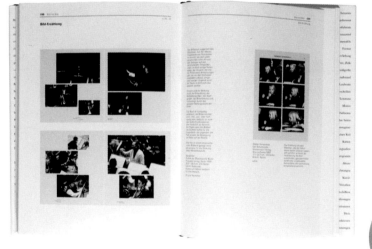

| Structure | Design: Hans Peter Willberg & Friedrich Forssman | Using the simplest means possible, *Lesetypographie* |
| 124/125 | Project: Lesetypographie | covers every possible aspect of typography. Printed |

Structure
124/125

Design: Hans Peter Willberg & Friedrich Forssman
Project: Lesetypographie
Authors: Hans Peter Willberg & Friedrich Forssman
Publisher: Verlag Hermann Schmidt, Mainz
Size: 303 x 215mm (12 x 8½in)
Pages: 332
Year: 1997
Country: Germany

Using the simplest means possible, *Lesetypographie*
covers every possible aspect of typography. Printed
almost exclusively in black and white, with a
light warm grey used as a background tint for
reproductions of page layouts, the book maintains
interest throughout by illustrating visually the
various principles of typography.

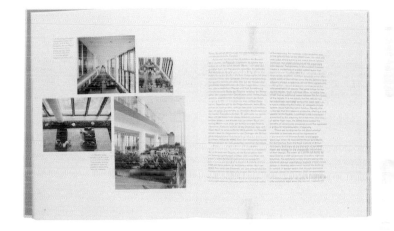

Design: Thomas Manss & Company

Project: The ARAG Tower

Editors: David Jenkins & Michael Mack

Publisher: Foster and Partners/
 ARAG Insurance Group

Size: 280 x 229mm (11 x 9in)

Pages: 144

Year: 2001

Country: United Kingdom

Produced to celebrate the completion of the
Foster & Partners-designed headquarters for the
German insurance company ARAG in Düsseldorf,
this bilingual book is case-bound and comes with
a transparent acetate dust jacket that relates to the
transparent façade of the building.

The book contains a series of architectural
essays and three photographic essays by three
different photographers who recorded the different
stages of the building's construction. These visual
essays are kept text-free by moving all caption
information to section divider pages, which include
cropped-in details of the images.

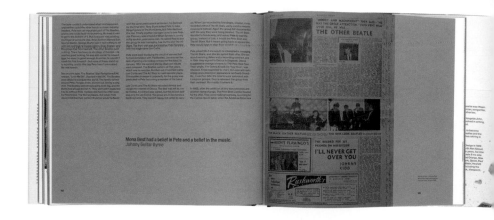

Image

Design: Rose Design Associates

Project: The Beatles – The True Beginnings

Authors: Roag Best, Pete Best & Rory Best

Publisher: Screenpress Publishing

Size: 247 x 290mm (9¾ x 11½in)

Pages: 200

Year: 2002

Country: United Kingdom

As its title suggests, this book deals with the early days of the legendary pop group, combining archival memorabilia and text printed in black and brown on uncoated craft stock. Surviving artefacts from the period have been beautifully photographed by Sandro Sodano and are given space to breathe on contrasting smooth white coated stock.

MY GOD, WHAT A DIFFERENCE, WHAT A TIGHTNESS.
IT HAD BECOME UNIQUE, IT HAD BECOME THEIR SOUND.
MIKE McCARTNEY

Design: Derek Birdsall
Project: The Technology of Man
Authors: Derek Birdsall & Carlo M. Cipolla
Publisher: Wildwood House
Size: 258 x 258mm (10⅛ x 10⅛in)
Pages: 272
Year: 1980
Country: United Kingdom

This collaboration between the writer Carlo M. Cipolla and the designer Derek Birdsall shows how well text and image can work together. Wherever possible, illustrations are reproduced as clean cut-outs with extended captions. The result is a fluent stream of words and images. The book flips between a clean white coated stock and a cream uncoated laid stock (paper on which small ridges are created during its manufacture), which works particulary well for line drawings and diagrams. The main body text is set in a single, wide measure in a large point size (14pt), to contrast with that used for the extended captions (7pt).

Design: HDR Design

Project: Alexey Brodovitch

Author: Kerry William Purcell

Publisher: Phaidon Press

Size: 298 x 258mm (11¾ x 10⅛in)

Pages: 272

Year: 2002

Country: United Kingdom

Charting the life and work of the great magazine designer/art director Alexey Brodovitch, this large volume beautifully reproduces both archival photographs and sequential spreads from many of his greatest works. The book has been designed sympathetically, using appropriate fonts favoured by the great designer: Bodoni and Futura.

The case-bound cover features a traditional quarter-bound spine – that is, the cloth over the spine extends onto the front and back boards, with the remaining three-quarters of the cover being bound in an uncoated stock. The use of traditional binding methods is extended to the dust jacket, on which a vertical blue rectangular strip is printed in the same position as on the quarter-bound cover.

Design: Base Design
Project: Terra: Miquel Arnal
Publisher: Miquel Arnal
Size: 200 x 300mm (7⅞ x 11¾in)
Pages: 72
Year: 2001
Country: Spain

Printed in black and two shades of grey, this book contains works by the Spanish photographer Miquel Arnal shot between 1990 and 1999. Two grey, 3mm-thick (⅛in) carton boards have been attached to the fabric cover; the cover image has been bonded to them and the title blind-embossed.

The rich black and white photographs are shown to advantage in this wide panoramic format. The different densities of black background give the images tremendous luminescence.

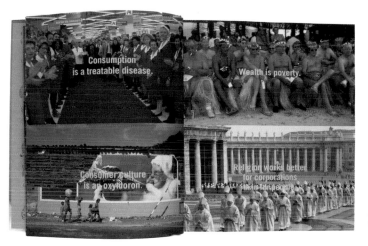

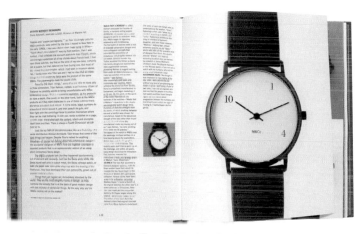

Design: Michael Bierut/Pentagram

Project: Tibor Kalman: Perverse Optimist

Authors: Peter Hall & Michael Bierut

Publisher: Princeton Architectural Press

Size: 248 x 209mm (9¾ x 8¼in)

Pages: 420

Year: 1998

Country: United States of America

This is a comprehensive monograph on the designer's work and ideas, with essays and commentaries by clients, collaborators, critics and friends. The text-free cover helps to turn the book into an object; only the word 'Tibor' appears on the spine.

The book reflects Kalman's own style by not following the conventions of book design: there is no title-page, or conventional introduction, but instead a series of eclectic full-bleed images with statements by the designer such as 'Success = boredom' and 'Rules are good. Break them' overprinted in yellow.

CONEY ISLAND
BRUCE GILDEN

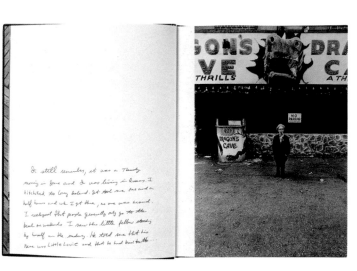

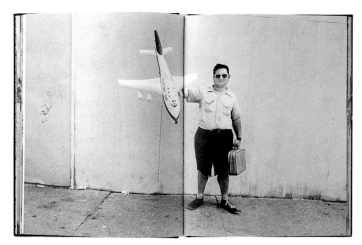

Design: Browns
Project: Coney Island
Photographer: Bruce Gilden/Magnum
Publisher: Trebruk UK
Size: 321 x 241mm (12⅝ x 9½in)
Pages: 108
Year: 2001
Country: United Kingdom

The cover of this photographer's book reflects the faded charm of the famous New York amusement park. Inside, the images are given generous space. Captions and personal thoughts and recollections are scrawled across the page in the photographer's own handwriting, an allusion to private photo albums that helps to personalize the book.

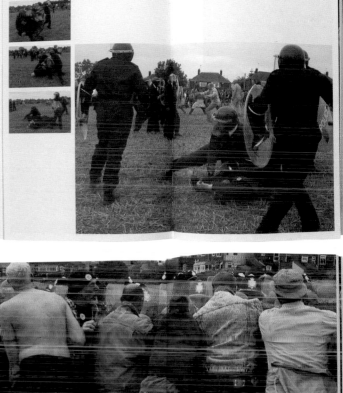

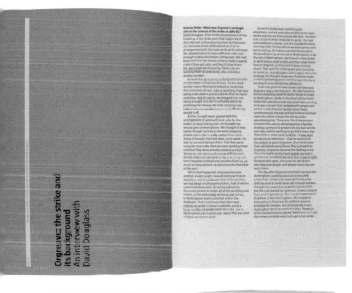

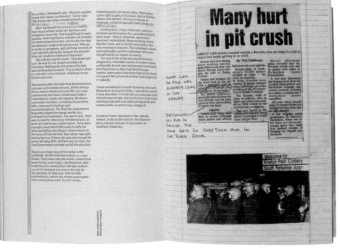

Design: Struktur Design

Project: The English Civil War Part II

Artist: Jeremy Deller

Publisher: Artangel

Size: 240 x 170mm (9¼ x 6¾in)

Pages: 160

Year: 2002

Country: United Kingdom

The English Civil War Part II was produced partly as a record of the actual Miners' Strike of 1984–85 and partly in order to document artist Jeremy Deller's reconstruction of the infamous 'battle' between miners and police at the Orgreave coal field during the dispute.

The main part of the book contains essays by people involved in the strike and features archival images and pages from scrapbooks.

These are predominantly printed in black and warm grey, with the occasional full-colour image. The final, colour section shows images from Deller's re-enactment. Folios and other information run vertically up the page in 4mm-wide (⅙in) strips of warm grey.

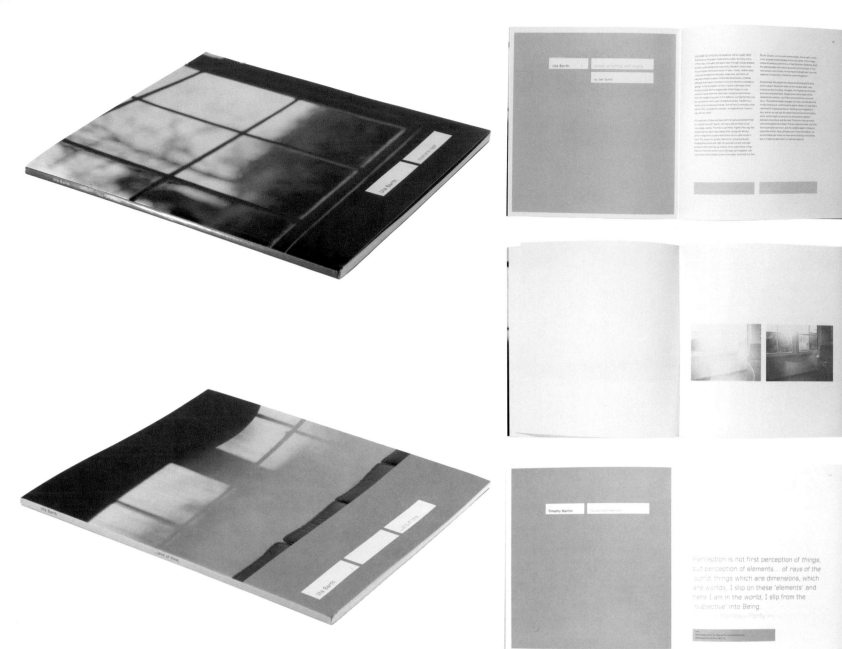

Design: Michael Worthington
Projects: Uta Barth: Nowhere Near &
Uta Barth: … And of Time
Publisher: Uta Barth
Size: 235 x 215mm (9¼ x 8½in) (each)
Pages: 56 & 40
Years: 1999 & 2000
Country: United States of America

These two books, produced in 1999 and 2000,
show the work of the photographer Uta Barth.
The same design scheme has been used in both.
This sets the often bleached-out images in large
areas of text-free white space. Both volumes have
essays at the back; these are set using a palette
of muted, pale colours that reflect the hue of
the photography.

Design: Michael Worthington

Project: Uta Barth: In Between Places

Publisher: The Henry Gallery Association

Size: 304 x 254mm (12 x 10in)

Pages: 176

Year: 2000

Country: United States of America

Containing essays, gallery views and full-page
images, this book has a variety of paces. Full-bleed
images continue on preceding and following
pages, contrasting with much smaller reproductions
which are given ample space in which to breathe.

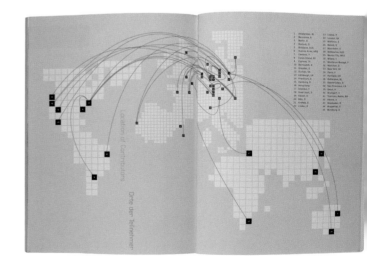

Design: Christian Küsters, Julia Guther & Anja Lutz
Project: Doubletake
Authors: Christian Küsters & Anja Lutz
Publisher: Shift!
Size: 225 x 165mm (8⅞ x 6½in)
Pages: 160
Year: 2001
Country: Germany

The creators of this book asked various people around the world to make a visual record of a day in their lives by taking 36 photographs – one every 20 minutes between 8am and 8pm. Having done this, contributors were requested to send their roll of unexposed film to a friend in another part of the world for them to repeat the exercise on the same film. The result was approximately 1,800 frames produced by the 100 collaborators. In the book, these double-exposed images have been laid out to chronicle the 12-hour period, with time-zone lines indicating the passage from one country to the next. The flow of images fluctuates, with both densely packed and sparser, more subdued spreads.

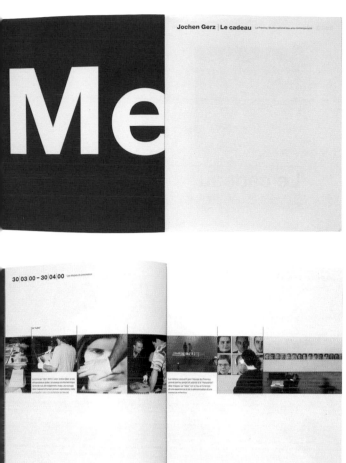

Design: Mark Diaper

Project: Le Cadeau

Publisher: Le Fresnoy, Studio National des
 Arts Contemporains

Size: 252 x 210mm (10 x 8¼in)

Pages: 720

Year: 2000

Country: Germany

When the artist Jochen Gerz invited the local community around Le Fresnoy in northern France to have their portraits taken for an exhibition at the museum, over 700 people participated. When the exhibition was over, everyone involved was given a large-format portrait of another participant. The book documents every stage of the process and reproduces all the portraits as full-page images.

The result is somewhere between a who's who and a telephone directory of the area. The word 'Merci' runs across the inside front and back covers.

The range of choices of paper stocks, printing techniques, and folding and binding methods is only limited by the designer's imagination or the publisher's budget. Some books require no clever pyrotechnics to advertise their worth; others can be transformed by an elaborate finish into highly desirable objects regardless of their contents. The following pages show a selection of some of the more beautiful things that can be achieved by deviating from the norm.

Specification

Interview:
Irma Boom,
designer

'It's strange to make a book, to work on it for five years and then have it end up in a safe, or in the homes of people that you don't know at all. Not many people can really talk about it, because nobody has read it.' Irma Boom is discussing the 2,136-page, 3.5kg commemorative book that she created with art historian Johan Pijnappel for SHV Holdings over a period of five years. It was finally published in April 1996.

It was completed over seven years ago now, but it remains the project that Boom is best known for. Although much has been written about it, to most people it remains an enigmatic object. The only people who have been fortunate enough to have the opportunity to study its thousands of pages are the 4,000 shareholders and board members of SHV. Anyone who has attended one of the many lectures that Boom has given on the subject will have had the chance to see the amazing tome in the flesh, but will not have been able to do much more than leaf through it quickly.

Boom feels that it's a shame that more people haven't actually read it: 'I think the contents of that particular book are so much more interesting than the look of it. And nobody can be aware of the inside because nobody has a copy of it. When people talk about it, it's always superficial.' This is particularly frustrating as it took Boom several years to assemble the content: 'For three and a half years I did no design at all, I was just looking at text, images and ideas.' For those who are really determined to see it, there are currently two copies of the book residing in libraries in the Netherlands, one in The Hague and one in the University Library in Amsterdam, where there is now an Irma Boom Collection. Boom is pleased that a living designer is being honoured in this way. It also makes sense for the library to collect the books from the designer as they are made – along with a finished copy of the SHV book, Boom handed over some of her preparatory materials such as sketches and dummies.

Specification	Design: Irma Boom
140/141	Project: SHV Thinkbook
	Publisher: SHV
	Size: 226 x 170 x 114mm (8⅞ x 6¾ x 4½in)
	Pages: 2,136
	Year: 1996
	Country: Holland

Boom estimates that she has designed over 200 books in the last ten years or so. At first she worked exclusively for Dutch clients; now she works with people from all over the world. 'The Dutch are very good because the tradition of commissioning is so good. They really understand what your job is and what their job is.' Working with publishers and other clients in Italy is exciting, but comes with its own challenges: 'I have to take care of my design and how it is treated.'

More often than not, Boom is disappointed when she first sees the finished object. What really excites her is the journey that she takes to get to the end point: 'For me, the making process is the most interesting part, especially the time when I have a dummy made and start to put the images in.' For the SHV book, she made hundreds of models, including some that used many different types of paper – she even went to India and made paper herself. Despite the fact that she loved making the models, she rejected the idea of using handmade paper: 'I hate craft – I like things to look very industrial.' One of her trademarks is the die-cut holes that she used extensively in the SHV book as well as in various pieces for Vitra. Another is her use of the edge of the paper: 'It's really my domain. If I can't add much to a book, at least the edge will be mine.'

Like many of her peers, Boom makes many of her design decisions while she's actually designing. This continues even into the very final stages of production: 'I'm always changing things, which makes people really tired. Some binders won't work with me any more.'

Although she is best known for her more involved, long-term projects, Boom also does her fair share of projects with a turnaround of a week or two. If she can't immediately find an idea she likes, she will simply wait until she gets an inspiration – a luxury few designers can afford and one that requires very understanding clients. In fact, it is this 'charmed' relationship with her clients that gives rise to the criticism most commonly levelled against her work – her 'self-indulgence' and the fact that she puts so much of herself into each piece, sometimes at the expense of the subject matter. For instance, some felt that her recent book on Otto Treumann contained too much Boom and not enough Treumann. They may be right, but most of her clients are commissioning her precisely because of this.

A recent project entitled *The Road Not Taken* for artist Job Koelewijn is typical Boom. It's a 720-page book containing the same poem printed 300 times, with a print run of 123. The jacket is based on a simple bouillon-cube pack and, to complement the cover design, the glue has been impregnated with concentrated bouillon, giving the whole book a (not totally unpleasant) smell of soup.

Irma Boom's books inspire strong emotions – people either love them or hate them. But even those that don't care for them have to acknowledge her influence on book design. Recently, an opportunity presented itself for someone to get their hands on her *magnum opus* when a copy of the SHV book came up for auction in Amsterdam. It was the first time that a copy had been made available to purchase, but judging by the fact that it was sold for 600 euros, it's probably not going to be the last.

Project: Otto Treumann
see page 84

Materials

Design: Olaf Bender, Jonna Groendahl &
 Carsten Nicolai
Project: Auto Pilot: Carsten Nicolai
Publisher: Raster-Noton
Size: 230 x 170mm (9 x 6¾in)
Pages: 104
Year: 2002
Country: Germany

Part monograph, part artist's book, *Auto Pilot* contains interviews and essays about the musician, fine artist and record-label founder Carsten Nicolai. A discreetly mounted CD is housed in the inside of the front cover, mounted on a white central spindle. The disc is visible through a small circular aperture, which gives a small blast of colour to the otherwise minimal cover design. Inside, the text runs concurrently in German and English, illustrated by images of Nicolai's installation work. Halfway through, the book transforms itself into an art installation: a 16-page section of clear acetate sheets is printed with solid black panels, creating complex layered images of black as the pages are turned.

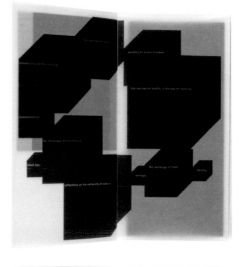

Design: 2GD/2graphicdesign

Project: ToC.2GDIV: Introduction to the Strategy
 of Aesthetic Creation…

Publisher: 2GD

Size: 200 x 100mm (7⅞ x 4in)

Pages: 128

Year: 2000

Country: Denmark

The full title of this book is 'Introduction to the
Strategy of Aesthetic Creation as a Process of
Pendular Reflection and Expression Producing an
Agenda for the Representation of Identities'.

Entirely printed in black and magenta on
tracing paper, the concertina-folded pages slowly
reveal ever-more layers of information and images
as the book is traversed. The magenta ink is
printed on the inside of the concertina folds, with
the black on the outside; this helps to diffuse the
vibrancy of the magenta and strengthen the black
text. The looseness of the binding allows the
book to be easily opened up and interacted with.

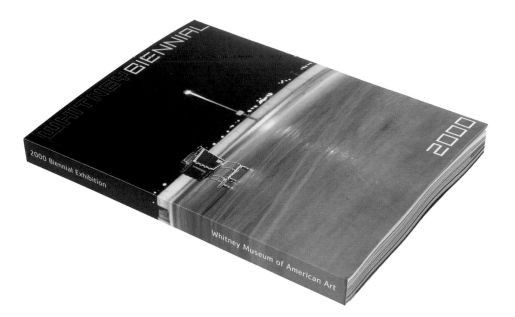

Design: J. Abbott Miller/Pentagram
Project: Whitney Biennial 2000
Publisher: Whitney Museum of Modern Art
Size: 255 x 202mm (10 x 8in)
Pages: 272
Year: 2000
Country: United States of America

This addresses a problem customarily faced by documentation of exhibitions of this nature: how to sequence a book that includes images that do not necessarily bear any relation to one other. The use of an interleaf page for text allows the book both to compare and segregate individual works. These interleaves are cut 25mm (1in) shorter than the rest of the book and use an uncoated yellow stock to add contrast. The 'seam' created by these

short pages allows an advance glimpse of the next artist's work, without distracting from the current one. A series of artists' biographies at the end of the book uses the same yellow stock.

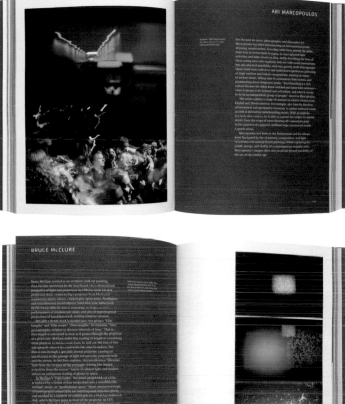

Design: J. Abbott Miller/Pentagram
Project: Whitney Biennial 2002
Publisher: Whitney Museum of Modern Art
Size: 255 x 205mm (10 x 8in)
Pages: 292
Year: 2002
Country: United States of America

This follows on from the project shown on page 144, dispensing with the trimmed edge but continuing with the interleaving. At first glance, the interleaves appear to be printed in pale blue on a brown uncoated stock. However, on closer inspection the stock turns out to be pale blue, and the text is printed out of a solid brown background. This system is reversed at the back of the book: the bibliography uses the same pale-blue stock,

with the text printed in brown. There is also a cover-mounted CD in a recessed hole, which allows the CD to sit flush with the cover board.

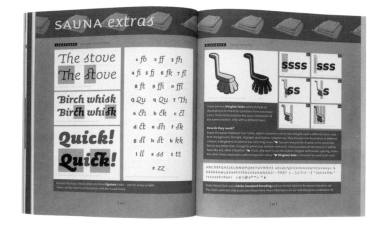

Design: Piet Schreuders & Underware
Project: Read Naked
Publisher: Underware
Size: 205 x 184mm (8 x 7¼in)
Pages: 48
Year: 2002
Country: Holland

Specially produced to withstand saunas, this book is resistant to hot steam of up to 120°F. Indeed, some elements are only visible when viewed inside a sauna at 80°F and above. The book gives guidelines on drying the book out after use; methods include baking, microwaving and drip-drying on a clothesline.

Produced to promote a new typeface called Sauna, the whole book has a strange, plasticized quality owing to the heat treament. The pages are bound together by stitching that passes from front to back. Again, the binding method is resistant to extreme heat and humidity.

three cats flower

howls

newsstand newspaper

Design: Thomas Manss & Company
Project: Gueorgui Pinkhassov: Sightwalk
Publisher: Phaidon Press
Size: 288 x 301mm (11⅛ x 11⅞in)
Pages: 44
Year: 1998
Country: United Kingdom

Case-bound in a hard, reptilian, textured purple material, this book of Tokyo images by the Magnum photographer has a very dramatic presentation. Inside, the French-folded pages have been sewn through from front to back. A special blue-tinted metallic paper adds an unusual piquancy to the vibrant colour photography.

A grid device introduced on the title-page as an embossed pattern appears again on the contents page, showing all 25 images featured in the book. The same grid is again used further on for the chapter dividers, which are printed in solid black on a heavy tracing paper with the grid windows left clear.

Design: Browns
Project: Pandora's Box
Photographer: Susan Meiselas/Magnum
Publisher: Trebruk UK
Size: 200 x 300mm (7⅞ x 11¾in)
Pages: 92
Year: 2001
Country: United Kingdom

The book's dark S&M sexual overtones are
reflected in the tactile qualities of the materials
used in its production, which include latex, rubber,
PVC and coloured gels. Blank divider pages printed
in dark reds and blacks act as dark corridors leading
from one room of extreme experiences to another.
Mirror paper is also used, turning the voyeuristic
reader into a participant within the pages.

esign: Base Design
roject: Khmer
ublisher: Fundación Francisco Godia
ze: 300 x 240mm (11¾ x 9½in)
ages: 76
ear: 2002
ountry: Spain

This was produced to coincide with an exhibition of Cambodian sculpture dating from the 6th to the 13th centuries. As such, the design needed to create a suitably relaxing pace and mystical ambience. The photographs of sculptures are printed on black backgrounds. Between the pages of each spread, a sheet of delicate black uncoated paper has been inserted to allow each image to be viewed in isolation. The divider pages show the Buddhist temples of Cambodia.

The cover is case-bound in black cloth and features saffron typography, a combination inspired by the traditional garb of Buddhist monks.

Print

Design: Hideki Nakajima
Project: Sampled Life
Publisher: Code
Size (box): 308 x 230 x 38mm (12⅛ x 9 x 1½in)
Pages: 195 (Score and Interview)
Year: 1999
Country: Japan

Produced to accompany the Japanese musician Ryuichi Sakamoto's opera *Life*, this lavish piece houses four books – *Score and Interview*, *Diary*, *Pictures* and *Text* – in a sealed white cardboard box, plus a series of differently shaped cards showing fragments of the musician's body.

The first book, *Score and Interview* (210 x 210mm; 8¼ x 8¼in), contains an interview with the composer in both English and Japanese. On every

page, there is a central square keyline box 110mm (4¼in) across, with lines connecting it to boxes on the left and right – the left-hand box contains a question, the right-hand box the answer. The text area is defined by the parameters of these boxes, but sometimes the text breaks free and extends over part or all of the page, though always maintaining a square format. The text is printed in a variety of subtle shades of grey. The score,

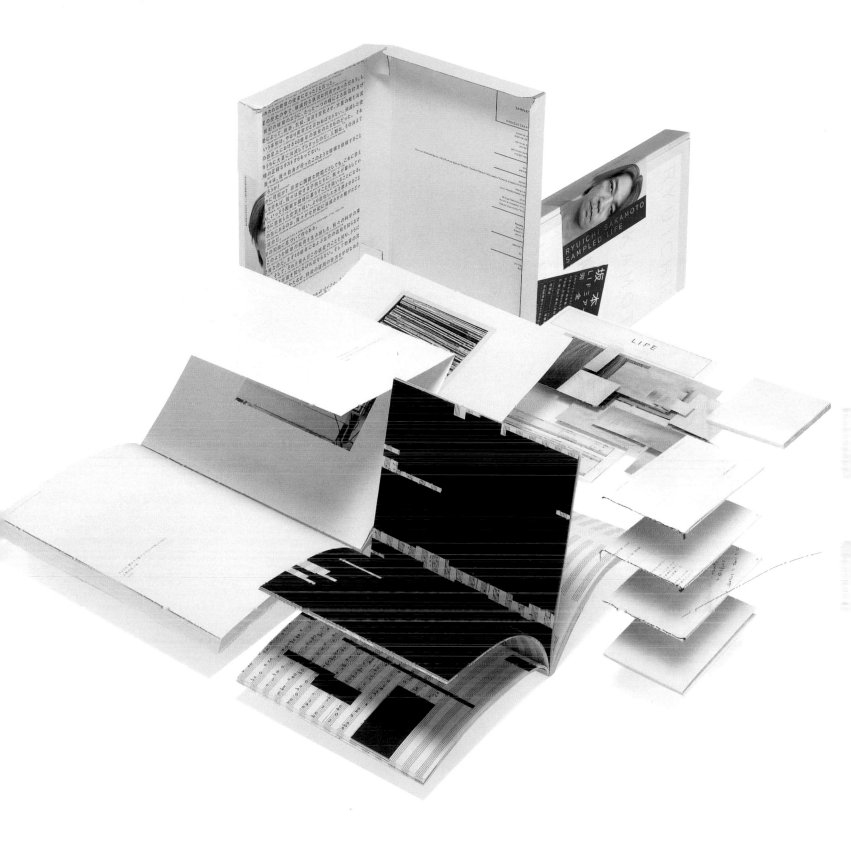

which fills the majority of this book, shows pages from the composer's sketchbook. Pages featuring abstracted musical score sheets give the whole book energy and rhythm.

The cover is pure white, with the title embossed on a gloss stock.

Design: Hideki Nakajima
Project: Sampled Life
Publisher: Code
Size (box): 308 x 230 x 38mm (12⅛ x 9 x 1½in)
Year: 1999
Country: Japan

Diary has a loose cover, using the same white gloss stock as *Score and Interview* but with the embossed title printed with an off-white varnish. Very thin lines in the varnish of the cover form a subtle grid.

Inside this small book (87 x 122mm; 3⅜ x 4¾in), three separate red-thread-sewn sections are loosely collated. With the exception of a small quantity of bleached-out photographs, the thread provides the only colour in the whole package.

Pictures is another small-format book (87 x 87mm; 3⅜ x 3⅜in). Perfect-bound, it contains a series of black and white images of war and peace

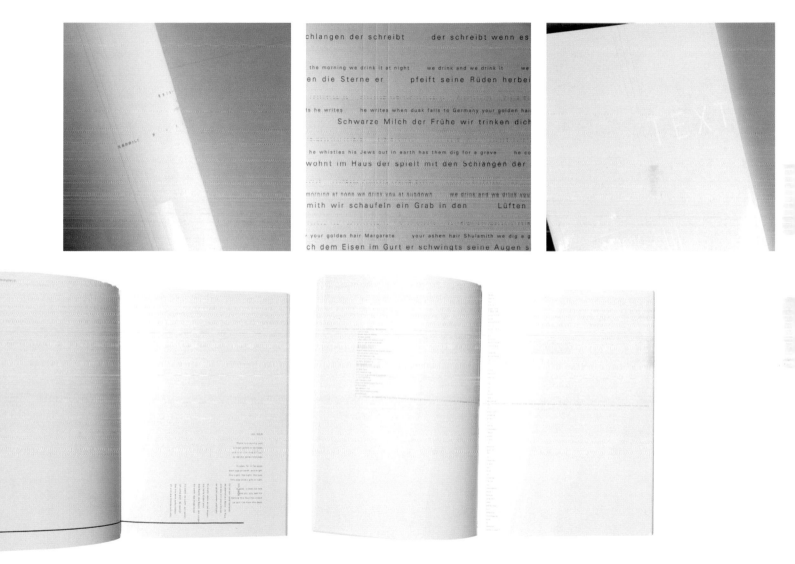

Text is the largest (297 x 212mm; 11¾ x 8⅜in) and most lavish of all the books in the package. The cover, printed on the same high-gloss white board as those of the other three books in the set, features a series of grid lines debossed into the surface. These lines appear on every subsequent page of the entire book. The spine is printed with luminescent ink, which radiates a green light in the dark.

Inside, text in English, German and Japanese is sparsely printed throughout the book. Some elements of the typography have been highlighted with a spot varnish; elsewhere, black or white lines are printed over the text, so that only a fragment at top and bottom remains visible.

The second half of the book comprises a set of 16 fold-out pages. These fold-outs have a very light adhesive applied to the surface, which forces the reader to peel the pages apart. These semi-hidden pages reveal a series of images of the composer's studio, recording equipment and personal artefacts.

Design: Chris Ashworth
Project: Soon: Brands of Tomorrow
Editors: Lewis Blackwell & Chris Ashworth
Publisher: Laurence King Publishing
Size: 295 x 248mm (11⅝ x 9¾in)
Pages: 192
Year: 2001
Country: United Kingdom

The front cover of this conceptual book about what 'brands' could become in the not-too-distant future uses heat-sensitive ink. The title only becomes fully visible when the cover is touched or exposed to warmer ambient room temperatures. The first 'o' of the title is printed in white; the other three characters of 'Soon' are only subtly visible. Inside, a series of nonexistent products are given branding makeovers.

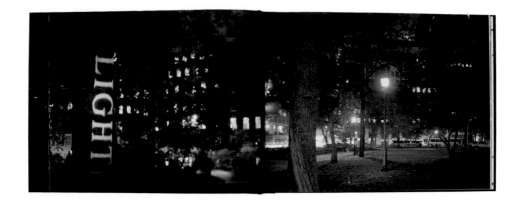

Design: Mark Diaper

Project: Tony Oursler: The Influence Machine

Publisher: Artangel

Size: 216 x 275mm (8½ x 10⅞in)

Pages: 104

Year: 2002

Country: Germany

This book relates to two audiovisual site-specific installations mounted in New York and London in 2000. These involved projecting images and texts at night onto the surrounding environment. The nocturnal nature of the work is reflected in the use of 'glow-in-the-dark' ink for the title on the front and spine of the book.

Inside, the book is broken into three sections: the first 32 pages, which are printed on a coated stock, feature images of the installations. The rest of the book is printed on an uncoated stock. The image section is followed by a contents page and a series of essays; the final section comprises a timeline running from the 5th century BC to the present day.

Design: Walker Gellender
Project: Icons. In the Beginning…
Publisher: Levi's Vintage Clothing
Size: 220 x 165mm (8⅝ x 6½in)
Pages: 48
Year: 1999
Country: United Kingdom

The cover is cloth-bound and pigment-blocked using two matt colours. Inside, however, the book is screenprinted in ten colours. The illustrations were first drawn at A3 size in black line on white overlays and the registration was done by hand. The colouring process then involved allocating each of the ten colours to a different overlay, which meant that the printer's proofs were the

first stage at which anybody saw a colour version of the book.

The whole book runs as a single concertina-folded document, which is bonded to the inside front and back covers. This means that the spreads spring towards the reader as the pages are turned.

Design: Hector Pottie
Project: Overprinted Forms of Everyday Objects
Publisher: Hector Pottie
Size: 252 x 194mm (10 x 7⅝in)
Pages: 24
Year: 2002
Country: United Kingdom

Produced as a limited-edition screenprinted artist's book, this plays with silhouetted forms of everyday objects and explores how they become abstracted when they are overprinted. Produced in red, black and warm grey on a grey uncoated stock, the pages have been simply sewn down the centre to form a binding.

Design: Aufuldish & Warinner
Project: A Contemporary Cabinet of Curiosities
Publisher: California College of Arts and Crafts
Size: 235 x 184mm (9¼ x 7¼in)
Pages: 52
Year: 2001
Country: United States of America

This book was produced to accompany an exhibition about the idea behind the 'cabinet of curiosities' – in effect, the precursor of the modern museum. To emphasize the idea that these cabinets were assembled by their owners, the book itself must be completed by its purchaser. The plates have to be tipped in – they come as a set of self-adhesive stickers tucked in an envelope at the back of the book. Grey monotones of the images appear on the appropriate pages to indicate where the colour plates should go. The typography continues the idea of assembly by using a custom-designed face (New Clear Era). Typographic flourishes and old medical illustrations complete the visual vocabulary.

esign: North

roject: Marc Quinn

ditors: Christoph Grunenberg & Victoria Pomery

ublisher: Tate Publishing

ze: 234 x 166mm (9¼ x 6⅝in)

ages: 134

ear: 2002

ountry: United Kingdom

Produced to accompany an exhibition by the artist Marc Quinn at Tate Liverpool, each of the six sections of this book is printed in two special colours on different-coloured uncoated stocks. The result is far more striking than anything that is usually achieved by using the conventional four-colour process on white stock. Eighteen full-colour A5 plates are interspersed throughout the book, contrasting with the multicoloured work-in-progress, sketchbook quality of the rest of the design. The designers have playfully used abstracted, coarse halftone screens of images in dot and line, which give the piece even more energy. The finished book is far from a conventional artist's catalogue, with the work cushioned by oceans of white space.

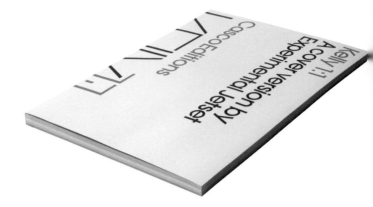

Design: Experimental Jetset

Project: Kelly 1:1

Publisher: Casco Editions

Size: 297 x 210mm (11¾ x 8¼in)

Pages: 300

Year: 2002

Country: Holland

This book is part of an installation produced by the design company Experimental Jetset for Casco Projects. The installation was a 'cover version' of an Ellsworth Kelly painting from 1966, *Blue, Green, Yellow, Orange, Red*. Experimental Jetset's version consisted of 150 sheets of A4 paper printed to match the original, then applied to a wall to form the five coloured square panels of the painting. The book is made up of the 150 sheets of coloured paper, and therefore constitutes a 1:1 reproduction of their transcription.

Contents

Secret and
unspoken paths

Valerie Walkerdine

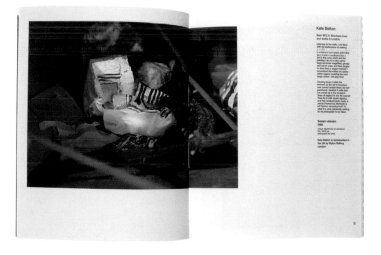

Design: Michael Nash Associates & Jane
Project: Girl
Editor: Angela Kingston
Publisher: The New Art Gallery, Walsall
Size: 265 x 208mm (10½ x 8¼in)
Pages: 60
Year: 2000
Country: United Kingdom

Produced to accompany the exhibition of the same name, the book plays with the idea of 'girlieness' and handmade crafts. The title is printed in bright pink gingham on a black background. A machine-sewn line of blue thread cuts through the typography and wraps around onto the back cover where it also bisects the ISBN, which is again printed prominently in pink. A block of gloss varnish is printed in the top left of the cover as a counterbalance to the symmetry of the title. The gingham pattern is also used on the inside front and back cover.

Engineering

Specification
162/163

Design: UNA (Amsterdam) Designers
Project: 2003 Diary
Publisher: UNA (Amsterdam) Designers
Size: 240 x 199mm (9¼ x 7⅞in)
Pages: 378
Year: 2002
Country: Holland

UNA continued their tradition of producing ever more elaborate diaries with this, their latest offering. It experiments with Plek and Flek, a new font designed by David Quay for the Foundry which is made from a series of overprinted circles.

Each spread of the diary is produced by roll-folding a long sheet of bible paper and creating a French fold with a loose central sheet which acts as a screen preventing show-through. These central sheets are printed in a different colour for each month, so producing a subtle colour shift a the year progresses. The fore-edge of the French fold is perforated along the fold, allowing the internal colour to be revealed.

Design: Struktur Design
Project: Minutes (2003)
Publisher: Struktur Design
Size: 224 x 164mm (8¾ x 6½in)
Pages: 36
Year: 2002
Country: United Kingdom

This is the second diary in a series of three which began in 2002 with *Hours* and which will conclude in 2004 with *Seconds*. It has been produced as a 3m-long (3yd) concertina-folded sheet with grey boards on the front and back. The front is printed in fluorescent pink, warm grey and black, with the reverse in black with white text printed out of it. The year is broken down into its constituent minutes, all 525,600 of them, to form a long string of 5pt numbers printed in fluorescent pink. This is then used as a typographic foundation for the days, weeks and months to hang off. The back of the book features a more conventional diary.

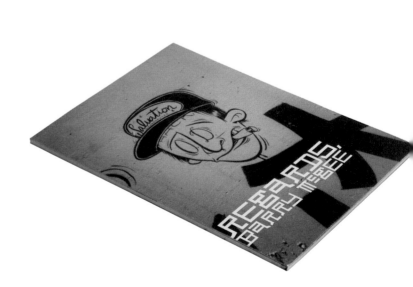

Specification
164/165

Design: Purtill Family Business
Project: Regards, Barry McGee
Publisher: Walker Art Center
Size: 210 x 152mm (8¼ x 6in)
Pages: 40
Year: 1998
Country: United States of America

The book consists of five large sheets of paper (420 x 304mm; 16½ x 12in) that have been folded twice to create the final page size. They have been carefully glued along the folded edge by means of the same strong adhesive used on notepads, but the book can also be disassembled to form a series of larger-format broadsides. It can be read in two ways: the 'folded' spreads are printed in black and white and contain essays and document the artist's source materials; the spreads can then be 'unfolded' to reveal full-colour images of a gallery installation.

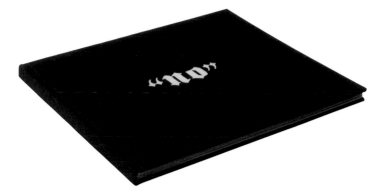

Design: The Kitchen

Project: No

Publisher: Levi's Vintage Clothing

Size: 218 x 244mm (8½ x 9⅝in)

Pages: 72

Year: 2002

Country: United Kingdom

The title is derived from a quotation by Albert Camus: 'What is a rebel? A rebel is a man who says "No".' It features nine fold-out sections. The folded pages contain information about collectable vintage clothing. They can also be opened up to reveal large photographs of the clothing and, as shown here, printed directions for use of both the book and the clothes.

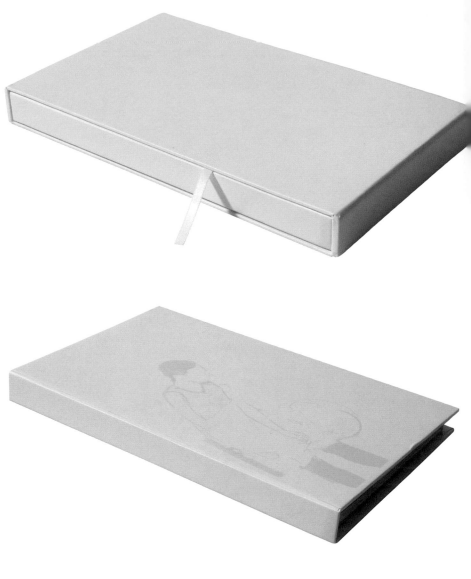

Design: 3 Deep Design
Project: Bird
Publisher: 3 Deep Design
Size: 275 x 168mm (10⅞ x 6⅝in)
Pages: 188
Year: 2002
Country: Australia

The outer slipcase of this beautiful book is very discreet, featuring just the title foil-blocked in clear varnish. A ribbon is secured inside the slipcase to aid the removal of the book. The book block is considerably smaller than both the outer case and the cover, and is bonded to the back of the cover. This allows the cover to be opened flat to reveal the glue and cloth of the spine. Inside, the illustrations are both printed and sewn directly onto the page to create a 'precious' quality for the piece.

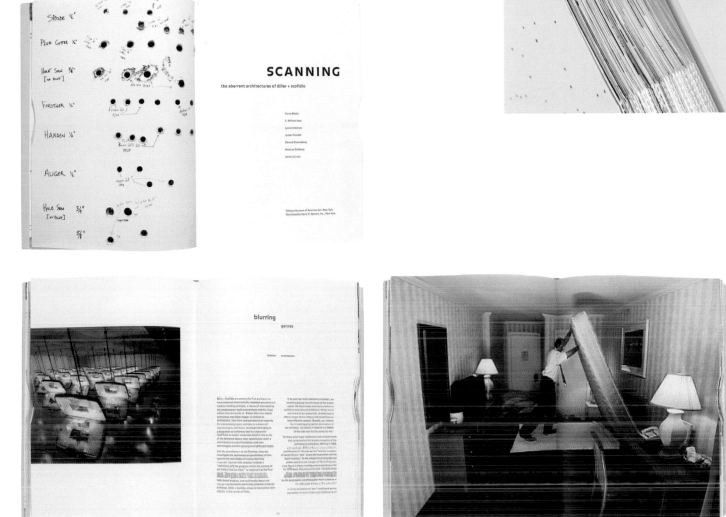

Design: J. Abbott Miller/Pentagram

Project: Scanning: The Aberrant Architectures
 of Diller + Scofidio

Publisher: Whitney Museum of American Art

Size: 292 x 207mm (11½ x 8¼in)

Pages: 192

Year: 2003

Country: United States of America

This was produced to accompany an exhibition of the work of the experimental architectural practice Diller + Scofidio. The cover features a lenticular image of a syringe morphing into a glass containing a lime-green substance. Inside, the book works on two levels. In the first place, it functions as a conventional retrospective of the company's work. However, the French-folded pages, which are perforated along the fold, can be opened to reveal a voyeuristic underworld of screen grabs from surveillance cameras watching office and hotel interiors. A die-cut curve along the fore-edge of the book allows an advance glimpse of the interiors of these French folds.

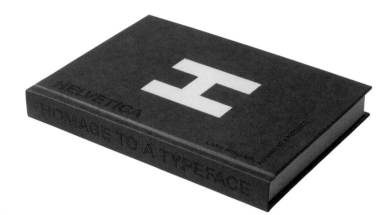

Design: Lars Müller

Project: Helvetica: Homage to a Typeface

Author: Lars Müller

Publisher: Lars Müller Publishers

Size: 164 x 124mm (6½ x 4⅞in)

Pages: 256

Year: 2002

Country: Switzerland

This small, densely packed pocket book works on two levels. On the outside, the perforated, French-folded pages contain a vast selection of printed examples of the Helvetica typeface in use. By ripping apart the French folds, the reader can then reveal a series of photographs showing the font in its more public guise – on billboards, street signage, etc.

do you ever see in black and white?

do you have anger in you?

I DARE YOU

Design: Park Studio
Project: I Dare You
Publisher: Park Studio
Size: 83 x 111mm (3¼ x 4⅜in)
Pages: 784
Year: 2001
Country: United Kingdom

This miniature handbound artist's book contains some 400 questions, which lead the reader to ever more tricky answers. It is printed on untrimmed bible paper, so the reader is dared to rip the pages open or else to keep them intact and instead meekly peer inside in order to read the text.

Specification
170/171

Design: Stefan Sagmeister & Anna-Maria Friedl
Project: Handarbeit
Editors: Peter Noever & Rick Poynor
Publisher: Schlebrügge.Editor
Size: 148 x 105mm (5¾ x 4⅛in)
Pages: 84
Year: 2002
Country: United States of America/Austria

Produced to accompany an exhibition of Stefan Sagmeister's work in Austria, the cover of this A6 book was specially created by the designer. A 20mm-diameter (⅞in) hole has been drilled through the book; the hole is just the right size to allow the reader to introduce his or her index finger into it. Inserting a digit into the hole from the back creates a typical Sagmeisteresque effect at the front. Internally, the clean two-column grid takes account of the die-cut hole. Texts in German and English are separated by a section of colour plates in the centre of the book.

Design: Experimental Jetset
Project: Anarchitecture
Publisher: De Appel
Size: 185 x 125mm (7¼ x 4⅞in)
Pages: 88
Year: 1999
Country: Holland

This was produced to accompany a group show of the same name. The cover features a keyline frame with two diagonal lines printed in process cyan; the title appears twice. These elements are then repeated on virtually every page of the book.

A small hole has been drilled through the entire book. This means that, used in conjunction with a sheet of undeveloped photographic paper, the book can be used as a primitive pinhole camera.

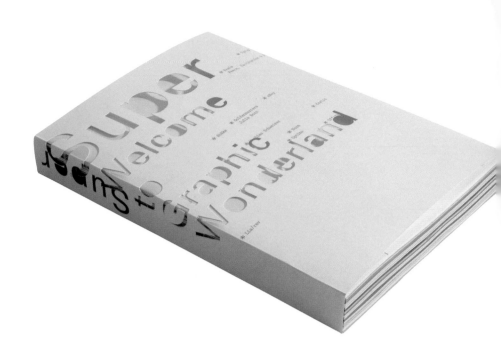

Binding

Design: Benzin
Project: Super: Welcome to Graphic Wonderland
Editors: Thomas Bruggisser & Michel Fries
Publisher: Die Gestalten Verlag
Size: 240 x 166mm (9¼ x 6⅝in)
Pages: 412
Year: 2003
Country: Switzerland

The dust jacket of this book of contemporary graphic design features the title die-cut out of a vibrant fluorescent background. As these delicate die-cut letterforms extend around onto the spine, the book's beautiful binding is exposed. The sewn sections have not been encased in a traditional cover, but instead remain exposed.

A series of small thumbnails are shown at the front of the book and illustrate each section by the different contributing designers. These very distinct sections are separated from one another by a sheet of uncoated craft paper.

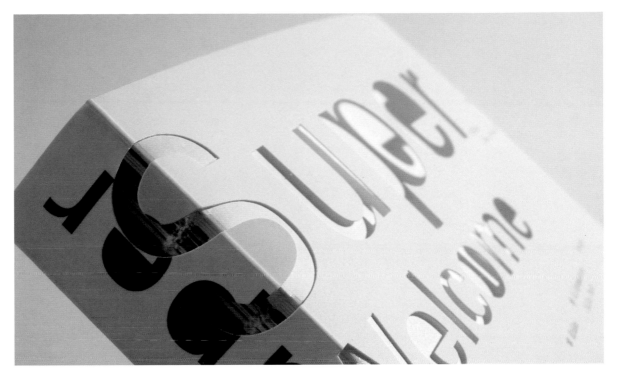

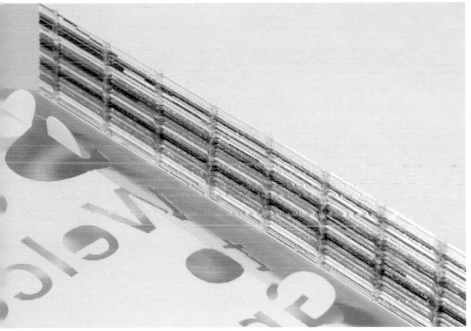

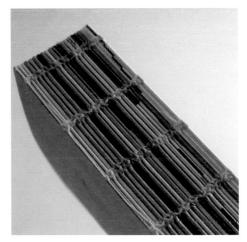

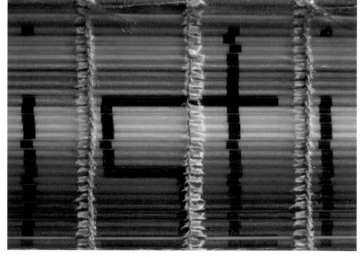

Specification
174/175

Design: Raban Ruddigkeit
Project: Freistil
Publisher: Verlag Hermann Schmidt, Mainz/
 Raban Ruddigkeit
Size: 240 x 175mm (9½ x 6⅞in)
Pages: 476
Year: 2003
Country: Germany

This book showcases the best in current German commercial illustration. The cover boards make use of a special metallic mirrorboard which refracts colour. The resulting rainbow effect is carried across onto the spine, where the edge of each of the folded sections is printed in a different shade from the rainbow. The title of the book and publisher's imprint are also reproduced in the same way, by printing a fragment of the letterforms on each folded section. The book is a bilingual edition with the German text printed in black and the English in cyan.

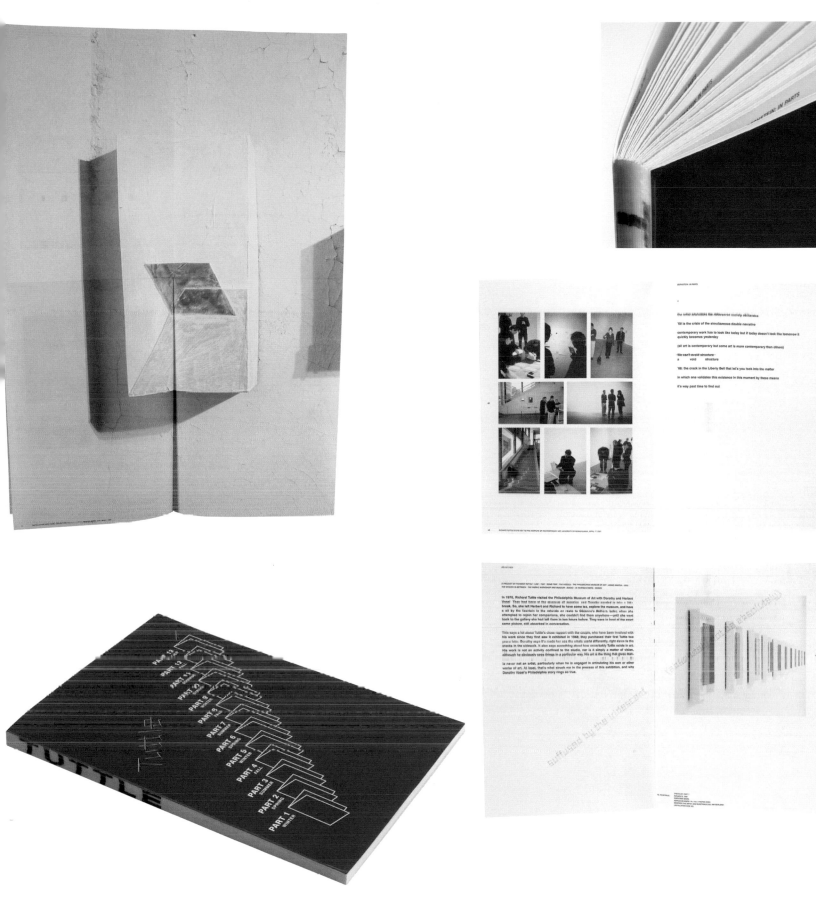

Design: Purtill Family Business
Project: Richard Tuttle: In Parts 1998–2001
Publisher: Institute of Contemporary Art,
 University of Pennsylvania
Size: 241 x 166mm (9½ x 6½in)
Pages: 52
Year: 2001
Country: United States of America

This book reproduces, at actual size, a series of paintings called *Painted Boxes*, which were specially photographed so that the cracking wall of the original installation would be visible. The 13 reproductions are printed in the fold-out sections of the book. In the exhibition itself, the book was dismantled and hung in parts across from the actual *Painted Boxes*, exactly replicating the works. The folded pages of the book contain an essay by Ingrid Schaffner and a poem by Charles Bernstein; both are split into 13 parts, one for each of the sections. The artist's name has been carefully printed on the folded sections of the spine.

Design: Base Design
Project: Serge Leblon
Publishers: Serge Leblon/Base Design
Size: 255 x 212mm (10 x 8⅜in)
Pages: 68
Year: 2000
Country: Belgium

The only embellishment on the book's clean white slipcase is a series of black dots representing the letters of the photographer's name. Within the slipcase, the book has been physically turned inside out, so that the first page is actually page 35. The cloth case-bound cover is found halfway through the book, with the photographer's name embossed into the surface in a dot-matrix font, reflecting the sequence of dots on the cover.

The reader's impulse is to fold the book's cover back to how it should be. Owing to the tightness of the binding, however, this proves to be impossible.

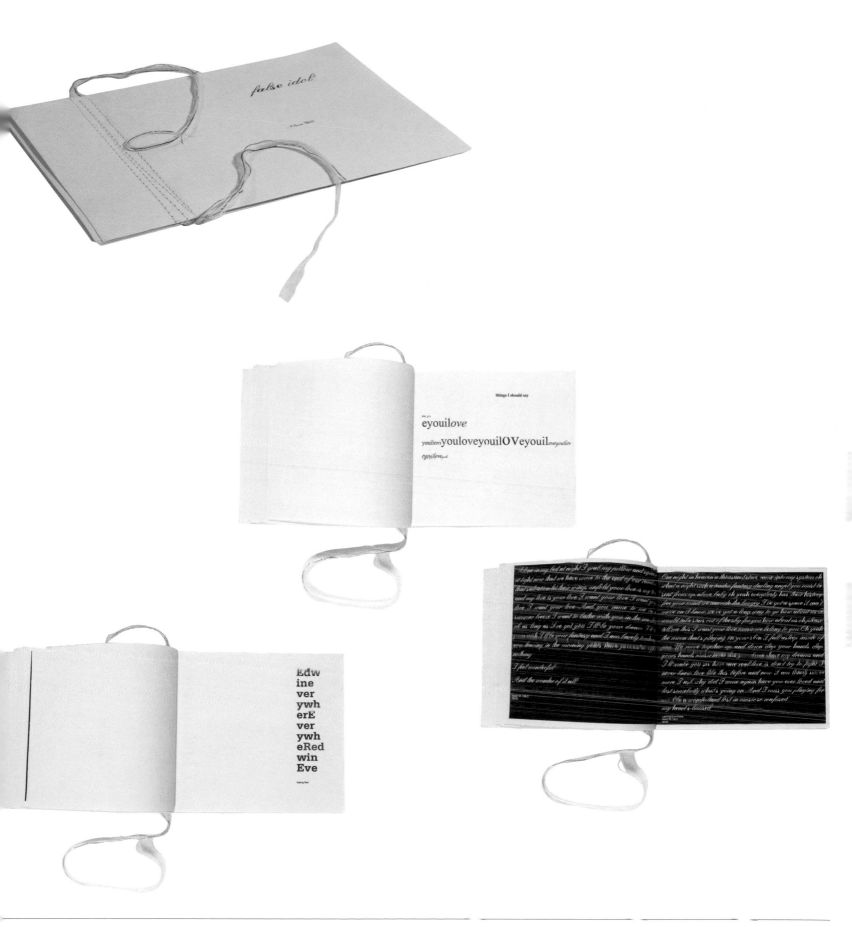

Design: Walker Gellender

Project: False Idol

Publisher: Alison Gibb

Size: 148 x 210mm (5¾ x 8¼in)

Pages: 28

Year: 2001

Country: United Kingdom

Hand-produced to order by the poet, this small book of verse can be altered and edited where necessary. The A5 pages are output on an inkjet printer and bound together using a domestic sewing machine. The resulting threads are left long and loose, which gives the work a delicate, feminine quality.

"Sucker is a triptych, a climax countdown captured on canvas"

Design: Walker Gellender

Project: Blank Canvas

Publisher: Levi's Vintage Clothing

Size: 297 x 210mm (11¾ x 8¼in)

Pages: 36

Year: 2000

Country: United Kingdom

This was produced for an exhibition of original works of art produced on vintage denim.

The book's cover was screenprinted with the contributors' names in red. A smear of white ink was randomly applied, making each cover unique. The pages were sewn through but left unfolded, allowing the end-user the option of folding the book or not.

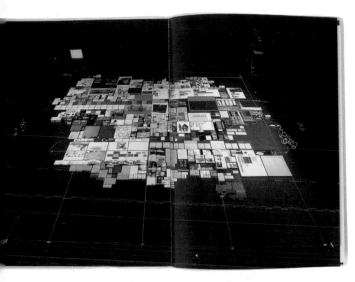

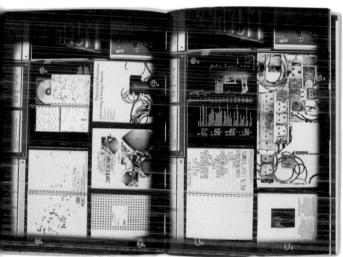

esign: Graphic Thought Facility
roject: Bits World
ditor: Emily King
ublisher: Gabriele Capelli Editore
ze: 210 x 148mm (8¼ x 5⅞in)
ges: 48 + 16
ear: 2001
ountry: United Kingdom

Two separate books are contained within a special clear PVC dust jacket. The main book illustrates the designers' output as photographed by a specially constructed rostrum camera: their work was laid out on the floor and driven over by the camera. Each item is given a project number relating to a caption contained in the second book, which is held in a pocket at the back of the jacket and which also contains an essay.

The dust jacket has a floral motif embossed into its surface. A small pocket around the spine houses a slip of paper with information about the title.

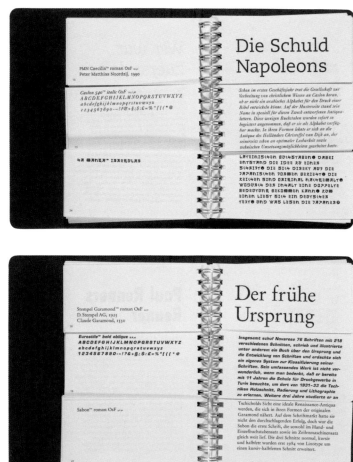

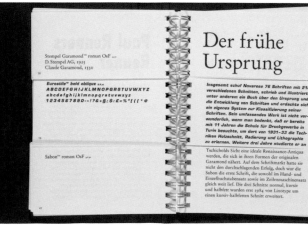

Specification
180/181

Design: Wiebke Höljes
Project: Schriftmischmusterbuch
Author: Wiebke Höljes
Publisher: Verlag Hermann Schmidt, Mainz
Size: 174 x 128mm (6⅞ x 5in)
Pages: 144
Year: 2000
Country: Germany

Created as an instant type style sampler, the pages of this small book have been sliced into three sections. The top section shows the 61 selected fonts as headlines (42pt); the middle and lower sections show the fonts at body-text size (12.5pt). As the book is wire-bound, the user can easily turn from section to section to compare different font combinations.

The book is housed within a simple card slipcase which bears a graphic line drawing that illustrates how the book is bound.

More than words can say

Jan Middendorp

les Landes, December 1996

Clotilde Olyff is no reader. She is not at ease with sentences, and not particularly fond of words. She is troubled by letters when arrayed for battle, preparing to strike the reader as useful information or gripping ideas. But she is positively in love with the letter as an individual, fascinated by the infinite possibilities in suggesting its forms, eager to discover its features in the faces of strangers. Even though she makes a living by creating and re-creating letters, the way we perceive these forms continues to fill her with wonder. Is it our obsession with communication that makes us look for the alphabet in the simplest of forms – circles, triangles, squares ? Does it take a particular type of madness to comb the beaches of Les Landes in search of letters created, so

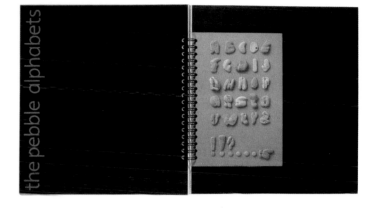

the pebble alphabets

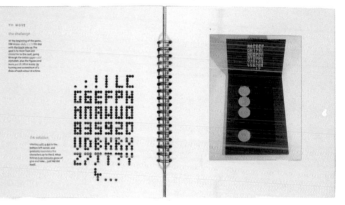

Design: Jan Middendorp
Project: Lettered
Editor: Jan Middendorp
Publisher: Druk Editions
Size: 235 x 210mm (9¼ x 8¼in)
Pages: 78
Year: 2000
Country: Holland

This book about the letterwork of Clotilde Olyff combines two different formats. Halfway through the book is placed a series of A6 postcards showing different pebble alphabets. The wire binding, which falls short of the length of the larger section of the book, matches the height of the postcards perfectly.

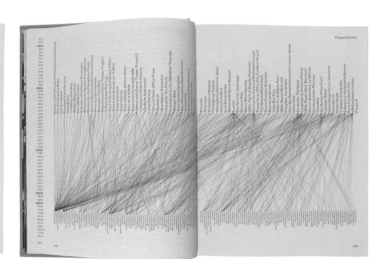

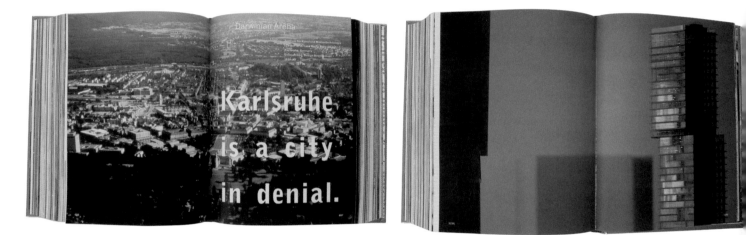

Small, Medium, Large, Extra-Large
Office for Metropolitan Architecture
Rem Koolhaas and Bruce Mau
Edited by Jennifer Sigler
Photography by Hans Werlemann
1995 010 Publishers, Rotterdam

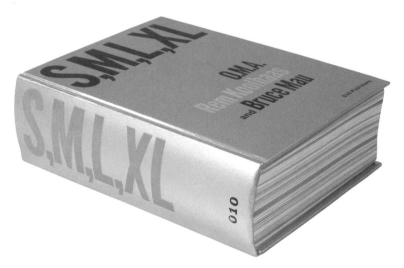

Specification	Design: Bruce Mau Design
182/183	Project: S, M, L, XL
	Editors: Rem Koolhaas & Bruce Mau
	Publisher: Uitgeverij 010 Publishers
	Size: 238 x 180 x 73mm (9⅜ x 7⅛ x 2⅞in)
	Pages: 1344
	Year: 1995
	Country: Canada

This book has inspired many equally weighty imitators. Conceived by architect Rem Koolhaas and designer Bruce Mau, it is divided into the four sections suggested by the title: small – i.e. private commissions by Koolhaas; medium – i.e. commercial developments; large – i.e. office blocks; and extra large – i.e. urban infrastructures. Far from being a conventional architectural monograph, the book generously gives Koolhaas space to air his thoughts, ideas and influences. Printed with specials, fluorescents and metallic inks, the book constantly changes pace and style.

Design: Sagmeister Inc.

Project: Sagmeister: Made You Look

Editor: Peter Hall

Publisher: Booth-Clibborn Editions

Size: 241 x 171mm (9½ x 6¾in)

Pages: 292

Year: 2001

Country: United States of America

When housed in its blood-red translucent plastic slipcase, the cover image appears to show a placid, happy-looking dog. This is transformed into a picture of a rabid, snarling wild animal when the book is removed from its case. This dual effect is achieved by printing the cover in red and green: the red plastic filters it to reveal only the green part of the image.

Images and text are also hidden along the fore-edge of the book. If the book is bent in one direction, its title becomes visible. When it is bent in the opposite direction, a series of bones are revealed. The book contains scribbled notes by the designer that give insights into his various projects.

Design: Made Thought
Project: Thinking Big
Publisher: Sculpture at Goodwood
Size: 154 x 215mm (6 x 8½in)
Pages: 48 + 176
Year: 2002
Country: United Kingdom

Held within an open-ended slipcase, this book about the artworks in the Goodwood Sculpture Park has a double-spine binding system. One book contains an essay, background information and biographical notes about each of the artists shown. The second, larger book is made up of lavish photographs by Richard Learoyd of details of the sculptures.

The binding method allows the two books to work together while maintaining physical independence. The cover wraps the two volumes together and features a full list of all the sculptures shown, including details of materials and size, foil-blocked onto it in silver.

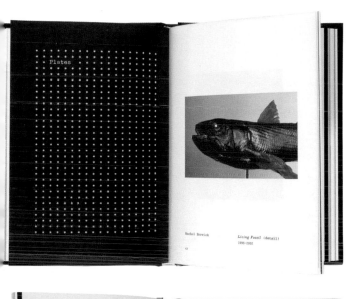

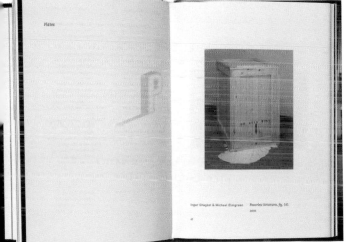

Design: Aufuldish & Warinner
Project: Sudden Glory/
 How Extraordinary That the World Exists!
Publisher: California College of Arts and Crafts
Size: 185 x 133mm (7¼ x 5¼in)
Pages: 120
Year: 2002
Country: United States of America

To save money towards an alternative art space, two exhibition books were combined into one. Each has its own front cover, so there is no 'back' cover as such. The books meet in the centre, in a 24-page, four-colour section that allows the plates for each exhibition to be reproduced in colour.

Each book has its own visual/typographic identity. *How Extraordinary* uses different kinds of monospaced and typewriter fonts to emphasize the mundane. *Sudden Glory* uses the edge of the text columns to make little typographic jokes. Hyphenated words are continued into the gutter and rendered in various ways.

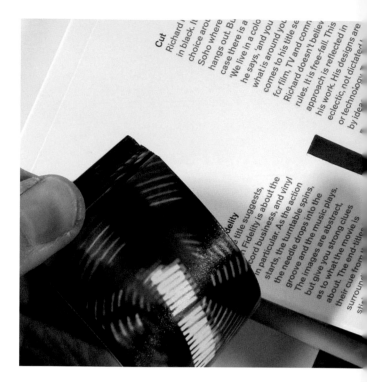

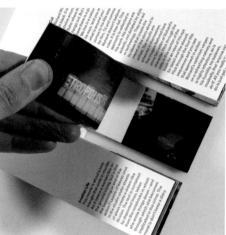

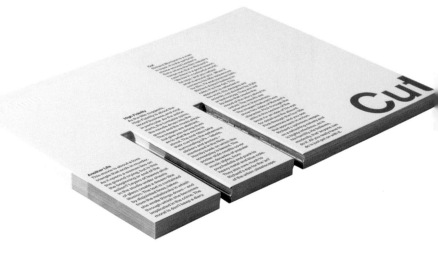

Design: Atelier Works
Project: Cut
Publisher: G.F. Smith
Size: 216 x 162mm (8½ x 6⅜in)
Pages: 108
Year: 2001
Country: United Kingdom

Featuring sequences of animated images by Richard Morrison, this flick book allows the viewer to look at each of the works independently. The book has two 7mm-wide (¼in) slots cut through the entire book; these allow it to be treated as three separate flick books. The biggest section contains photographs taken of ripped fly posters from around the world. The two smaller sections show four animated title sequences, which can be viewed by flicking the pages from front to back and back to front.

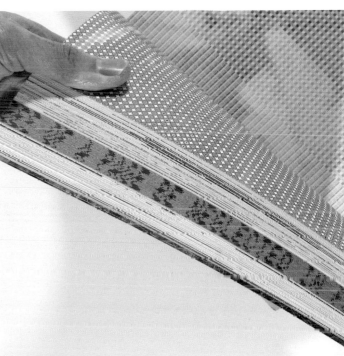

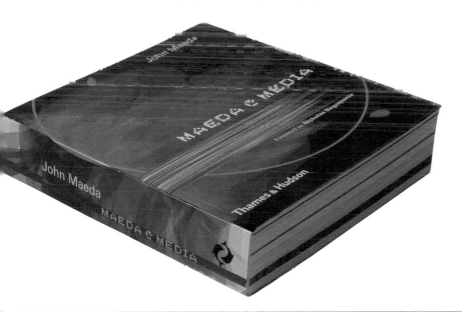

Design: John Maeda
Project: Maeda@Media
Author: John Maeda
Publisher: Thames & Hudson
Size: 223 x 207mm (8¼ x 8⅛in)
Pages: 480
Year: 2000
Country: United States of America

A stunning showcase of the designer's highly complex computer-aided art, this thick volume features very high-quality reproductions to allow Maeda's intricate sequential works to be convincingly rendered on the page. The book is printed on a variety of coated and uncoated stocks and features a section printed on a brown craft paper where the text has been extruded to the outer edges of the page. A statement reads:

'It is customary that the edges of the page be neglected in favor of its front and back.' Text on the edges of the pages only becomes legible when the book is bent as shown on the picture above – such an effect is achieved by printing fragments of the letterforms on each successive page.

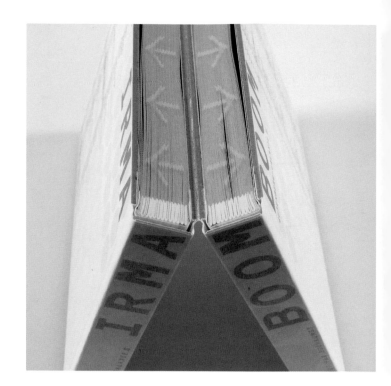

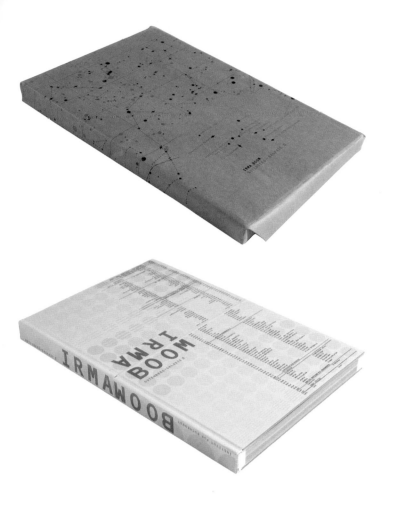

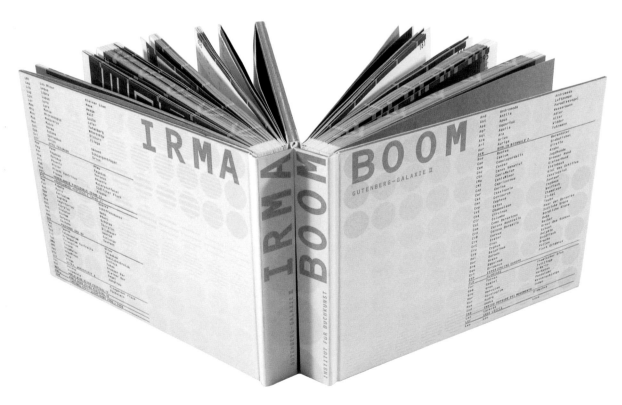

Specification
188/189

Design: Irma Boom
Project: Gutenberg-Galaxie II
Publisher: Institut für Buchkunst
Size: 290 x 193mm (11¼ x 7⅝in) unfolded
Pages: 208 x 2
Year: 2002
Country: Holland

The Gutenberg Prize is awarded by the city of Leipzig to a designer of outstanding merit. Previous winners have included Jost Hochuli; each is given the opportunity to produce a book entitled *Gutenberg-Galaxie*.

Irma Boom's project comes wrapped in a sheet of brown craft paper that shows a map of the galaxy. It looks at first like a standard portrait-format book, an illusion that is broken when the wrapping is removed to reveal instead two smaller, landscape-format volumes only held together by the paper of the back cover board. Once out of its wrapper, the work folds easily in half and becomes easier to handle.

The contents have likewise been split. One of the volumes features full-page reproductions of

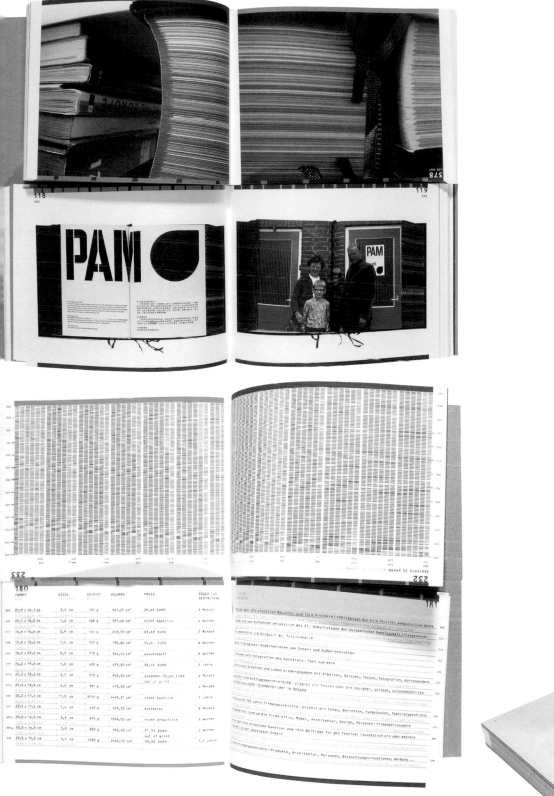

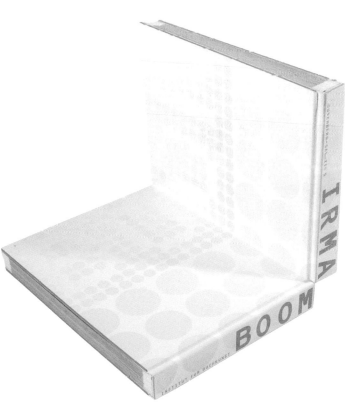

he designer's work; the other focuses on details
f these other projects such as the intricate
inding and printing techniques for which Boom
s famous.

Bellyband
A strip of paper or other material that wraps around a book to form a seal, like a belt.

Bible paper
Delicate, lightweight paper (40gsm), traditionally used for bibles and dictionaries.

Blind-embossing
The process of embossing a raised design into the surface of a material without the use of ink.

Book block
The main body of a printed book, without the covers.

Broadsheets
Large sheets of uncut paper which can be folded out into poster format.

Case-bound
Bound with hard covers.

Cast-coated paper
High-quality paper of which one side of each sheet has a high-gloss surface while the other side has been left with a rough finish.

Concertina folds
Pages that have been folded back and forth to form a zigzag pattern, like the bellows of a concertina.

Craft paper
A rough pulp paper, usually brown in colour, used mainly for packing.

Die-cutting
A process whereby intricate shapes are cut out of the surface of paper or board.

Divider pages
Pages in a book used to break the work into different sections. These are sometimes produced using a different stock or are cut to a different size from the rest of the pages in the book.

Dust jacket
A loose paper cover that protects the boards of a case-bound book.

Endmatter
The information at the end of a book, including such elements as the index, bibliography, credits, glossary, etc.

Flatplan
A diagrammatic representation showing all the pages of a book, used by designers to help them plan out a book at the development stage.

Foil blocking
A method of applying a thin film of metal or other opaque medium onto the surface of a sheet of paper or cover board. The foil is applied by pressure using a hot metal stamp.

Folios
The page numbers as printed on the pages of a book.

Fore-edge (or foredge)
The 'open' edge of a page in a book which runs parallel to the bound spine.

French folds
A method of binding whereby a sheet of paper is folded in half and the open ends are bound into the spine so that the fold forms the fore-edge of the book.

Glassine
A transparent paper similar to tracing paper, used for window envelopes.

Grid
Guide marks describing the structure of a page, used to help the designer maintain consistent positions for body text, folios, captions and images across a series of pages or whole book.

Halftones
A process used to reproduce an illustration which involves breaking it up into small dots of different densities to simulate a full tonal range.

Head and tail bands
Strips of ribbon sewn onto the top and bottom of the book block in case-bound books

Inks (specials, metallics, fluorescents)
Almost all mass-produced books are printed using lithographic inks. As a rule, full-colour printing is achieved by the combination of four process colours: cyan, magenta, yellow and black (CMYK). However, additional 'special' inks, such as fluorescents or metallics to create shiny gold or silver effects, can also be used to produce distinctive results.

Keyline
A thin line or rule.

Laid stock
Paper is mainly produced using one of two types of mould. A wove mould creates a smooth plain sheet. A laid mould creates a series of closely spaced parallel lines across the sheet, giving the surface a slightly ridged texture.

Lamination
The application of a clear matt or gloss protective film over the printed surface of a sheet of paper.

Lenticular images
Lenticular images create an animated effect when their surfaces are viewed from different angles. A clear plastic sheet containing a series of closely spaced parallel ridges is used to form a lens over a printed surface containing two or more different images, interspliced in parallel strips matching the ridges of the plastic lens.

Letterforms
The shape and structure of a typeface.

Monospacing
Some fonts give the same space for each character of the alphabet, so that a lower-case 'i', say, occupies the same amount of horizontal space on a line as an upper-case 'M'. Monospace fonts are most commonly used for tabulated information where uniform spacing is required.

Perfect binding
In this binding method, pages in the gatherings of a book are notched along their uncut edges to be glued together into the spine. The result is not usually as strong as on a thread-sewn volume.

Pigment blocking
A process similar to foil blocking, but using coloured film.

Preliminary matter (Prelims)
The information at the front of a book, usually including the publisher's details, copyright notices and the list of contents.

Process cyan
See 'Inks'.

Quarter-bound
This method of binding was traditionally used as a cheaper alternative to producing full leather case-bound volumes. A quarter-bound book has a leather-covered spine section which extends a quarter of the way onto the front and back cover boards, as this is the area of a book which needs the most protection.

Raster
An alternative method of halftone screening using an electron beam. It creates complex, irregular patterns of very fine dots and produces higher-quality images and colour work.

Recto
The front side of a sheet of paper, hence also the right-hand (odd-numbered) pages of a book.

Roll-folding
A process whereby a long sheet of paper is folded into panels or pages starting from the far right, with each subsequent panel folded back toward the left – effectively rolled back around itself.

Screenprinting
A printing method that applies ink onto the surface of the material with a squeegee through fine silk mesh. This process achieves a much denser application of ink than lithography and can be used on an almost limitless variety of surfaces.

Slipcase
A protective box into which the book slides, usually open at one end only to reveal the book's spine.

Spot colour
A special colour not generated by the four-colour process method.

Stock
The paper or other material a book is printed on

Thread-sewn
A durable binding method in which the different gatherings of a book are sewn together using thread.

Thumbnails
Small reproductions of page layouts, used by designers to view all the pages of a book simultaneously in order to check the overall flow of the design.

Tipping-in
A process in which images (colour plates) are glued onto the pages by hand.

Verso
The back side of a sheet of paper, hence also the left-hand (even-numbered) pages of a book.

Glossary

Index